PHOTOGRAPHING
NATURE IN ALASKA

ROBERT H. ARMSTRONG

Text and Photographs © 2010 Robert H. Armstrong

Published by:
Nature Alaska Images
5870 Thane Road
Juneau, AK 99801
(907) 586-6811

Edited by Marge Hermans Osborn
Reviewed by Arnie Hanger and Michael Penn
Designed by Matt Knutson of InterDesign

ISBN: 9781578334766

Printed by Everbest Printing Co. Ltd., Nansha, China
through **Alaska Print Brokers**, Anchorage, Alaska.

First printing, March 2010

Distributed by:
𝕿𝖔𝖉𝖉 𝕮𝖔𝖒𝖒𝖚𝖓𝖎𝖈𝖆𝖙𝖎𝖔𝖓𝖘
611 E. 12th Ave.
Anchorage, Alaska 99501-4603
(907) 274-TODD (8633) • fax: (907) 929-5550

with other offices in Ketchikan, Juneau, Fairbanks and Nome, Alaska
sales@toddcom.com • **WWW.ALASKABOOKSANDCALENDARS.COM**

Contents

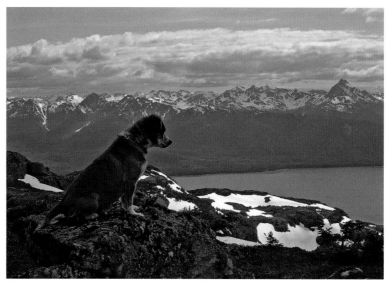

In Memory of Jake, 1989-2009

Acknowledgments

In the early years I learned a lot about photography from my sister Patty. She had a darkroom in the house and loved to take photos of nature. From her I learned that you could find an amazing variety of subjects to photograph in one small area–but you had to crawl about on your hands and knees.

I am especially grateful to the many naturalist, biologist, and ecologist type friends that point me in directions I would never have thought of on my own. Wandering about, looking, speculating, and documenting nature with photographs has been especially rewarding–Dan Bishop, Richard Carstensen, Richard Gordon, Kathy Hocker, John Hudson, Chuck O'Clair, Rita O'Clair, Dick Marriott, Greg Streveler, and Mary Willson.

John Hudson and Rich Merritt have always been available to help identify insects that I have photographed.

Getting involved with photography groups has also been influential. Alaska Society of Outdoor and Nature Photographers allowed me to write a monthly column for their newsletter which stimulated me to think in new directions. Attending the meetings of "The Alaska Photographic Arts Association" in Juneau continues to inspire me.

I always learn more about photography techniques by going on photo shoots with such friends as Steve Gilbertson, Arnie Hanger, Doug Jones, and Mark Schwan.

The encouragement I always receive from my frequent co-author Marge Hermans Osborn has inspired me to explore new photographic directions.

Introduction

Photography is my passion. Even while growing up in the State of Washington I always took a camera with me on hikes and backpacking trips. I loved to document what I saw and kept photo albums of all my trips.

When I came to Alaska in 1960, I purchased the biggest telephoto lens I could find. That started a lifelong hobby of photographing birds that has lasted for nearly 50 years. Since then my interest has expanded to taking photographs of anything to do with nature in Alaska. I've been especially interested in documenting the behavior and habits of Alaska's creatures. To do this I have experimented with a wide variety of techniques, including high-speed photography and the use of supermacro lenses and remote triggering devices.

My goal in writing this book is to share my enthusiasm for both photography and Alaska's natural world. The book is about what has worked for me and some of the stories behind the images. Much of the equipment I use is fairly low-cost and affordable. I have always avoided the most expensive and so-called "best" cameras and lenses. I firmly believe that

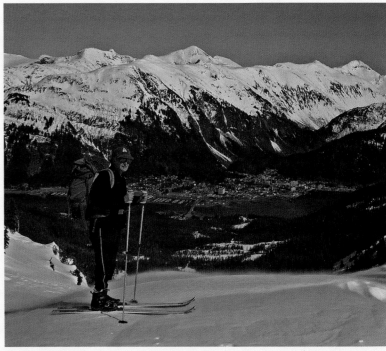

Photo by Ed Mills

it's the photographer that makes the difference, not necessarily the tools he uses. However, as you browse through this book you will realize that many different types of cameras, lenses, and just plain gadgets can help make certain images possible.

While I was reviewing images to include in this book I came to one major conclusion: Most of the photos I consider really exciting have come from Juneau, my Alaskan home town. Although I have traveled extensively in Alaska, and even lived in Fairbanks for a few years, the nature photographs I've taken outside of Juneau have been mostly portraits—the kind

The alpine is my very favorite habitat to explore. The photo above shows me standing at a place called Naked Man Lake on Douglas Island with the beautiful city of Juneau in the background on April 3, 2002. In the photograph to the left I am photographing marmots in the alpine above Juneau on August 3, 2006.

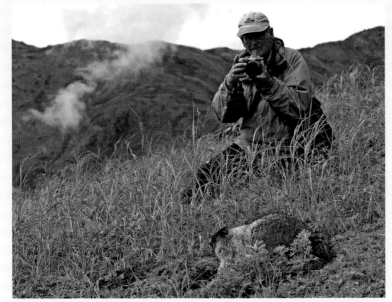

Photo by Arnie Hanger

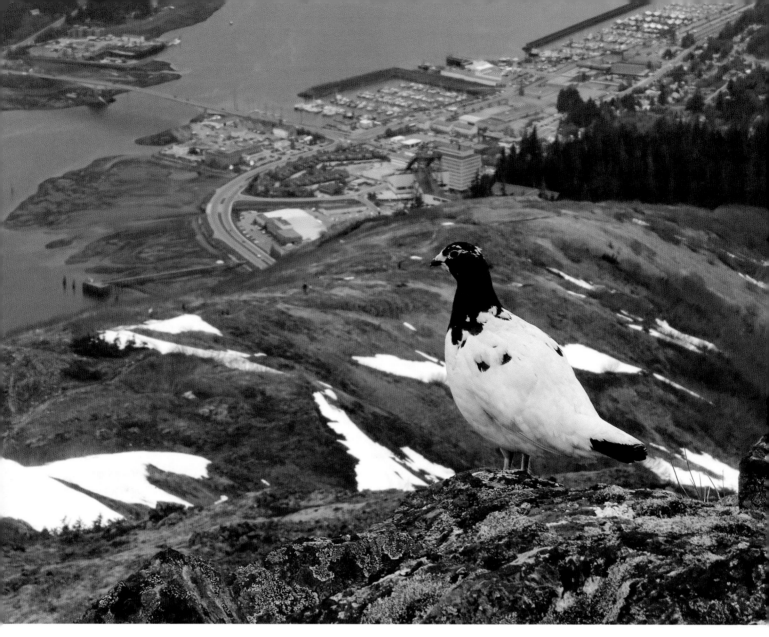

Panasonic DMC-FZ30, focal length 24mm, f/8 at 1/250 second, ISO equivalent 100, minus 0.7 exposure compensation, 5/30/06.

State Bird overlooking the State Capital. *It was a thrill for me to find and be able to photograph this male Willow Ptarmigan with Juneau in the background. I was able to approach and photograph this bird without causing it to flush.*

of photographs I call "a bird on a stick." While they may be beautiful in their own right, I would much rather capture creatures doing something. I want images that tell a story, and I believe these types of images are best achieved when you know an area intimately. This type of knowledge can be achieved through long-term wanderings and studying relatively small areas—places in your own back yard, so to speak. Visiting an area for a day or two or even a couple of weeks has seldom produced the type of images I desire.

One of the things I enjoy most about photography is that it has taught me a great deal about the natural world. It's a snowball effect with me—the more I learn the more I want to learn. I believe that learning about nature helps us to appreciate it and helps us become even more passionate about the wonderful creatures and other natural things that share Alaska with us. I hope my images and stories will stimulate others to learn more and, as a result, become more protective of Alaska's remarkable natural world.

The Cameras

I've used a variety of cameras over the years. At the beginning of my time in Alaska I especially liked to photograph birds, and I sat in blinds or wandered about with a huge Leicaflex telephoto lens complete with shoulder stock that resembled a military weapon. Once while I was photographing birds near the Juneau airport, a security officer with lights flashing, came across the runway and made me return to the terminal for interrogation. It took awhile to convince the officer that my "weapon" was really a camera.

 I eventually gave up completely on using 35mm cameras and transitioned into the digital world with a tiny point-and-shoot camera, which I now use primarily attached to a spotting scope in a technique called "digiscoping."

I often use the "prosumer" type cameras for applications where a high depth of field is important, or for photographing birds at nests, where it helps to have a silent shutter to avoid disturbing the bird.

 I also use a Digital Single Lens Reflex camera (DSLR), especially for action photographs.

Point & Shoot and Prosumer

Digital SLR's

Point-and-Shoot and Prosumer Cameras

Sooty Grouse and Mt. Jumbo. *This is the photo that convinced me that "point-and-shoot" and "prosumer" cameras had a much greater depth of field than did 35 mm and Digital SLR cameras. To get this much depth with an f-stop of only 2.8 is truly amazing.*

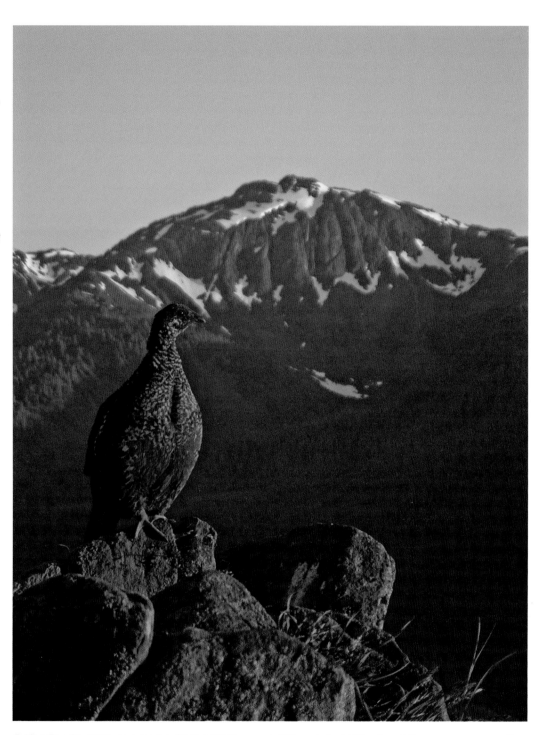

Fujifilm Fine Pix 4700 zoom camera, f/2.8 at 1/274 second, ISO equivalent 200, minus 1.2 exposure compensation, 7/19/01, 9 p.m.

Although photography has always been my passion, my energy for it started to wane about 10 years ago. My 35mm equipment was way too heavy and no longer enjoyable to pack around. Of course I needed several lenses, motor drive, and a sturdy tripod. Back then I did not trust the zoom lenses, so I needed a wide angle lens, macro lens, intermediate lens, and big telephoto. For best quality I did not want to go beyond Kodachrome 64, so to avoid camera shake I usually used a tripod. Also I was getting older.

Digital cameras were available, but the word was that they weren't good enough to equal the quality of 35mm cameras. I purchased one anyway to see what they were all about. It was a tiny 2.5 megapixel Fujifilm FinePix 4700 that fit into a shirt pocket and only weighed a few ounces. I liked the results it gave and carried it on all my outings. I thought it was neat to always have a camera with me and not worry about weight.

One evening around sunset I was hiking in the alpine and came across the Sooty Grouse pictured on the opposite page. The bird was quite tame and allowed me to approach within a few feet and take its picture. When I processed the image I noticed that the mountain in the background was almost in sharp focus. The mountain was a famous landmark in Juneau (Mount Jumbo), so I was quite pleased to be able to put the grouse in context with its surroundings. I had always envied painters who could put their subjects in the environment as our eyes see them. This was difficult and usually impossible with the shallow depth of field of 35mm lenses.

I was so excited about the grouse image that I went back up to the exact same spot with my 35mm Nikon camera and equivalent lens. I photographed the same scene, minus grouse, at several f-stops. The resulting photos were quite interesting. At the same f-stop (f2.8) and lens extension the mountain in the background was a complete blur. You could not even tell it was a mountain. Higher f-stops were better

but did not even approach the depth of field achieved with the little Fujifilm camera. I was hooked. Light weight and much greater depth of field made photography fun again.

For several more years I used only prosumer cameras and resisted the temptation to go heavy again and purchase a professional DSLR. Even today I often use a point-and-shoot camera (for digiscoping) and a prosumer camera for certain applications. Besides light weight and higher depth of field they have one other advantage for photographing nature—no shutter noise to scare away your subject. Also, you can view your subject with the LCD screen, which can help a great deal for close-up photography. Some even have movable LCD screens that help to focus when you're working near ground level. If all that wasn't enough, many models excel in doing macro work. Some can full-frame a mosquito and provide enough light without having to use extension tubes and special electronic flash setups that are usually necessary with the DSLR's and 35mm equipment.

Digital Cameras

For ease of discussion I will generally define the three types of digital cameras that I now use.

Point-and-shoot cameras are small, fit-in-the-shirt-pocket sized cameras. I currently use the Samsung Digimax V70/a7 mostly for digiscoping.

Prosumer cameras are medium-sized (but lightweight) cameras with a non-inter-changeable zoom lens with a long range of focal lengths. I currently use the Panasonic DMC-FZ-30 camera, mostly for remote work and for macrophotography.

DSLR (Digital Single Lens Reflex) cameras are fairly heavy and similar in size and weight to the 35mm film cameras, with approximately the same depth of field. They will accept interchangeable lenses. I currently use the Nikon D-300 mostly for taking action photos.

Weight

My prosumer camera, the Panasonic Lumix DMC-FZ30, weighs 1.6 lbs and is small enough

to fit into an easy-to-carry shoulder bag. It has a lens equivalent of 35mm to 425mm. My professional DSLR, the Nikon D-300 with similar lens coverage, weighs 6 pounds and requires a camera backpack to carry the equipment. Some prosumer cameras have incredible lens coverage (28-520mm, for example) and weigh only a few ounces.

What is "Depth of Field." Image clarity or sharpness is not just a matter of focusing a lens on the subject. There is an area in front of and behind the sharp focus plane that is also sharp or clear, and the extent of this area changes, depending on the focal length of the lens, the focusing distance, and the aperture used. This three-dimensional area of sharp focus is called depth of field.

Depth of field was calculated by using the calculator provided in www.dofmaster.com. Digiscoping depth of field can be determined from an Excel document provided by www.digibird.com. I have made a calculation of the 995 Nikon Coolpix attached to a 60mm Kowa TS-614 scope with a 20 power eyepiece. At full telephoto of the Coolpix this

A comparison of three camera types as to their depth of field when doing close-up work. The assumptions are: 35mm lens or equivalent, f-stop = f/11, distance from subject = 3 feet (distance useful for flowers or nesting birds in their natural setting).

Camera	Near Focus	Far Focus	Depth of Field
Prosumer (equivalent lens extension = 7mm)	1.33 feet	Infinity	Infinite
35 mm camera	2.41 feet	3.97 feet	1.56 feet
DSLR (full frame)	2.41 feet	3.97 feet	1.56 feet

A comparison of three camera types as to their depth of field when doing telephoto work. The assumptions are: 420mm lens or equivalent, f-stop = 5.6, distance from subject = 10 feet (distance needed for reasonable photos of small birds with a 400mm lens).

Camera	Near Focus	Far Focus	Depth of Field
Prosumer (equivalent lens extension = 89mm)	9.87 feet	10.1 feet	0.23 feet
35 mm camera	9.97 feet	10.0 feet	0.03 feet
DSLR (full frame)	9.97 feet	10.0 feet	0.03 feet

Depth of Field

Depth of field can be one of the most important aspects of obtaining a successful photo in nature. In macro photography you usually need a good depth of field in order to get an insect or flower in full focus. When using 35mm or DSLR equipment, successful macro work usually requires a tripod and sometimes electronic flashes in order to use a high enough f-stop to obtain the needed depth of field. Depth of field when using telephoto lenses can also make the difference in getting your subject in focus.

setup equals a 2,385 mm (35mm equivalent) telephoto lens. The Coolpix/Kowa combination at f5.6 focused at 100 feet would yield a depth of field of 1.17 feet. Using the same parameters a 2,385 mm (35mm or DSLR) lens (if they made one) would yield a depth of field of only 1 to 2 inches. Hence, digiscoping with "point and shoot cameras" will result in much greater depth of field than similar 35mm and DSLR lenses and even those much smaller.

In summary all of the above means:

If you set your "Prosumer Camera" at 35 mm equivalent (7mm) and f/11 and shoot your subject from three feet away everything from about 1.5 feet to infinity will be in sharp focus.

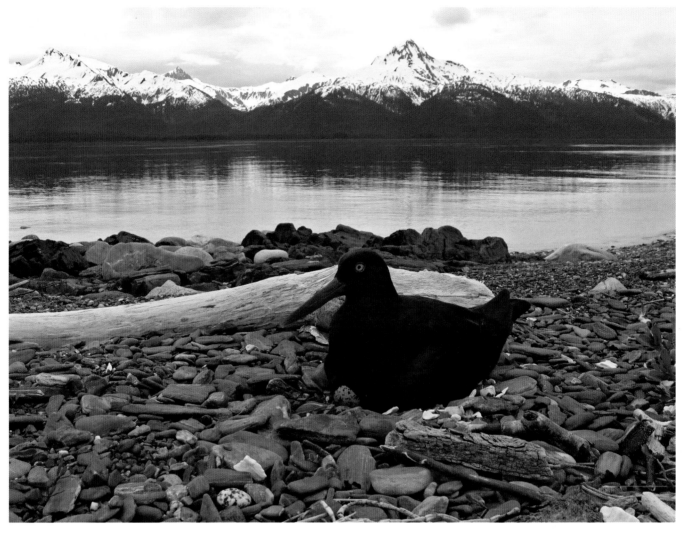

Panasonic Lumix DMC-FZ30, focal length 9mm, Pocket Wizard Plus II, f/8 at 1/200 second, ISO equivalent 100, minus 0.3 exposure compensation, 5/30/06.

This means you can put your flower or nesting bird in a setting that shows the surrounding forest, mountains, and water.

For macro work most flowers and insects will be in complete focus – especially if you use a higher f-stop. And best of all you can hand hold your camera.

When attaching a "point and shoot camera" to a spotting scope you can get enough depth of field to show your subject despite the incredible lens mm equivalents.

Black Oystercatcher on nest. *To get this photograph of the Black Oystercatcher I quickly set up the camera with a remote triggering device on a table tripod a couple of feet from the nest, and retreated to a point about 200 feet away. Within a few minutes the bird returned to the site and by watching it through binoculars I was able to determine the appropriate time to trigger the camera. I especially liked this photo because its egg was partly showing in front of the bird. The small size, silent shutter, and great depth of field of the prosumer camera helped to capture this scene. Also, the ability to compose the scene through a movable LCD screen helped shorten the setup time.*

7

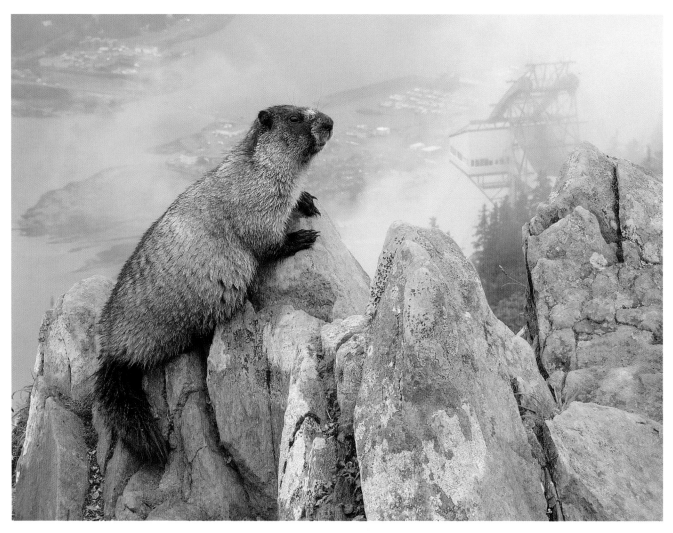

Panasonic Lumix DMC-FZ10, focal length 20mm, f/6.5 at 1/320 second, ISO equivalent 100, minus 0.7 exposure compensation, 7/11/05.

Hoary Marmot above the Tram. *A few years ago my co-author and I needed a cover photo for our book on marmots,* Whistlers on the Mountains, *so I was quite pleased to get this shot. It showed the marmot's important physical features well and, best of all, the upper Mt. Roberts Tram building showed in the background through the fog. This was important since the book was to be sold in the tram gift shop and nature center at the top of the tram. I felt the prosumer camera with its greater depth of field, silent shutter, and light weight (for me to carry in the alpine) helped to capture this image.*

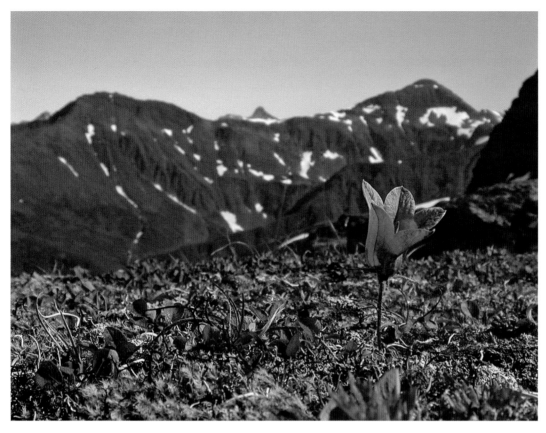

Nikon E995, focal length 8mm, f/7.5 at 1/568 second, ISO equivalent 100, minus 1 exposure compensation, 8/4/02.

Mountain harebell is a dwarf alpine species that often grows by itself. Though it is small, it also stands out amid lower-growing vegetation. I feel the top photograph captured its habitat really well. While the portrait photo to the right shows the flower quite well, it does not show the environment the flower grows in.

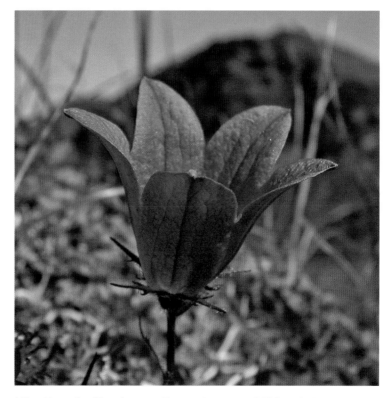

Nikon E995, focal length 11mm, f/7.4 at 1/713 second, ISO equivalent 100, minus 1 exposure compensation, 8/4/02.

9

Alp lily. These dainty lilies are only a couple of inches high, so I was quite pleased to be able to capture both the flower and the snowcapped mountain behind it.

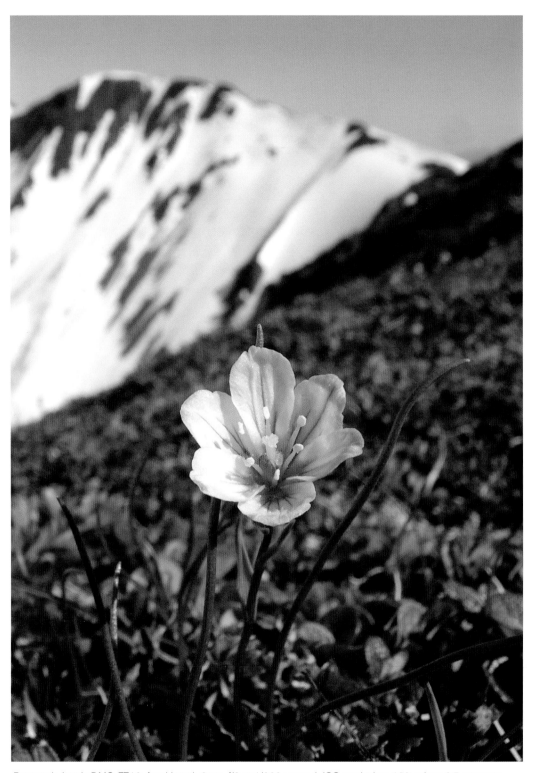

Panasonic Lumix DMC-FZ10, focal length 6mm, f/8 at 1/800 second, ISO equivalent 100, minus 0.7 exposure compensation, 6/18/04.

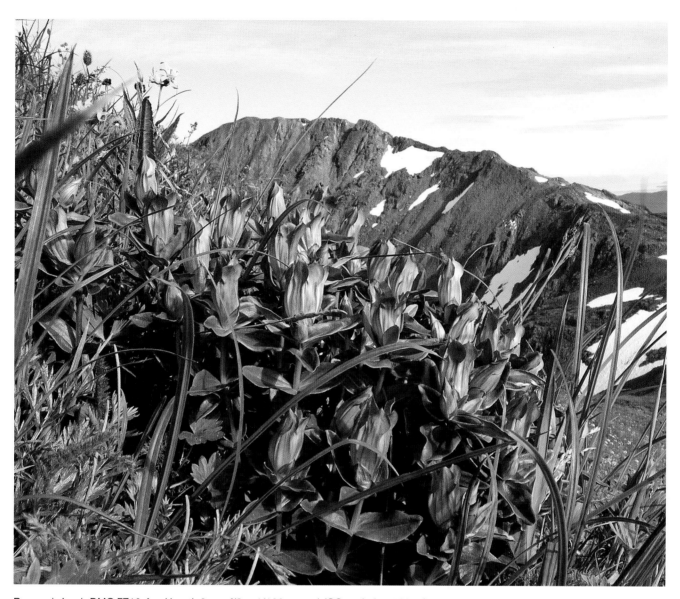

Panasonic Lumix DMC-FZ10, focal length 6 mm, f/8 at 1/160 second, ISO equivalent 100, minus 0.7 exposure compensation, 7/22/04.

Broad-petaled Gentian and Mt. Gastineau. *These gentians are one of my favorite alpine flowers. They are fairly large, open only in sunlight, and bloom clear through September. The prosumer camera allowed me to easily compose these flowers with a recognizable mountain in the background.*

Shutter Noise

Prosumer and point-and-shoot cameras make no noise when you take a photo (assuming you have turned the "beep" off in the menu). This can be a great advantage when photographing wildlife up close. Digital SLR's, like 35mm cameras, make a noise when you press the shutter release button.

For example, I used to photograph birds at their nest with 35mm cameras using remote triggering devices. On several occasions, when I watched a bird's reaction from a distance with binoculars or a spotting scope, at the sound of the shutter the bird would jump off the nest or act obviously startled.

With my Nikon D-300 DSLR, even when I was about 30 feet away from my subject the shutter going off would sometimes cause flight (for shorebirds) or a look in my direction (mammals).

I like to photograph birds at my feeder by making special natural scenes around the feeder, and I like to put a remote triggering device on the camera so I can photograph them from the comfort of my living room. When I first started using the DSLR, every time the shutter was clicked the birds would fly away. It usually took an hour or two before the birds would get used to the shutter noise.

The latest model of the Nikon D-300 has a much quieter shutter.

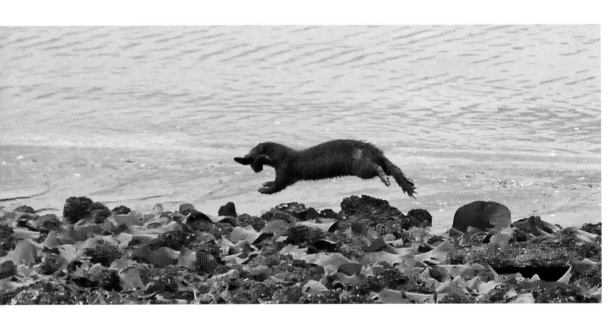

Nikon D-300, AFS Nikkor 70-300 mm lens, focal length 300mm, f/5.6 at 1/1250 second, ISO equivalent 3200.

That dang shutter noise. One example of the problems associated with shutter noise was when I was photographing a mink capturing fish and bringing them to its den. To get photos of the mink running along the beach with fish I hid behind a large rock and waited. I was about 50 feet away, so my photos were not very close. I wanted a closer photo, so I moved to about 20 feet from the den. When the mink ran back to its den with a fish, it seemed unconcerned about my presence. I pressed the shutter just before it was to emerge in full view with its fish. At the sound of the shutter the mink immediately dropped the fish, stopped and stared at me. As you will see on the next page, I missed the photo I was hoping for because of the shutter noise.

Nikon D-300, AFS Nikkor 70-300 mm lens, focal length 300mm, f/5.6 at 1/250 second, ISO equivalent 3200.

Using the LCD Screen

You can use the LCD screen for focusing most point-and-shoot and prosumer digital cameras. Some even have movable LCD screens. This can be a great advantage when doing ground level work (such as photographing a small flower) and is especially important when photographing insects. Insects may tolerate a small camera approaching them but not the head of a human attempting to view them through a viewfinder. Some recent DSLR cameras allow viewing through the LCD screen but I know of none that are movable.

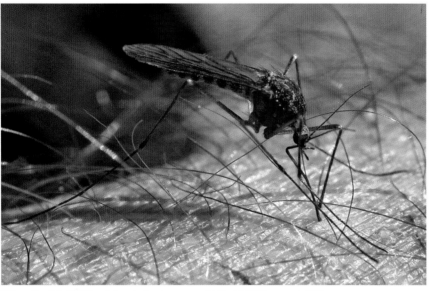

Nikon Coolpix E995 point-and-shoot camera, f/9.9 at 1/337 second, ISO equivalent 100, minus 0.7 exposure compensation, 5/7/03.

Mosquito and net-winged beetle hand-held, full frame. *This is a good example of the macro capabilities of some of these small point-and-shoot cameras. With 35mm or DSLR a full-frame photo of a mosquito or this small beetle would require extension tubes, possibly a tripod, and/or electronic flashes.*

Nikon Coolpix E995 point-and-shoot camera, f/7.8 at 1/72 second, ISO equivalent 100, no exposure compensation.

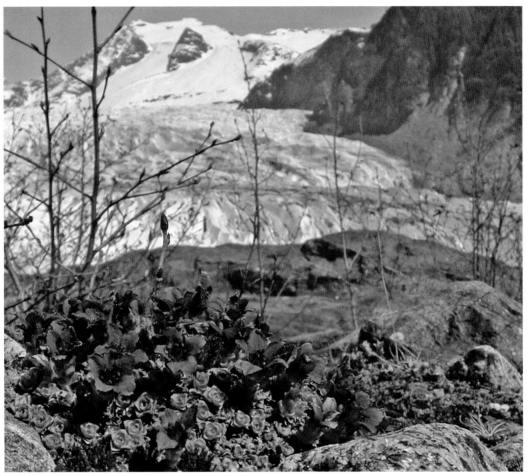

Purple mountain saxifrage in front of Mendenhall Glacier. *To keep the white glacier from bleaching out, I exposed for the glacier, which caused the flowers to become way too dark. I corrected that in Photoshop using Shadows and Highlights. Although the camera was set only a few inches from the flowers, the glacier and mountains came out reasonably sharp.*

Nikon Coolpix E995 point-and-shoot camera, focal length 8mm, f/7.8 at 1/72 second, ISO equivalent 100, 5/7/02.

Prosumer Camera Photo Tips

If there are any bright objects in a scene, such as white or yellow, you should use a minus exposure factor. This helps prevent the bright areas from becoming bleached out, without any detail. If you're photographing mature Bald Eagles, for example, usually a minus exposure factor of 0.7 to 1.5 will be necessary to bring out detail in a Bald Eagle's white head.

Since many prosumer cameras are so light, there is a tendency to hand-hold them when they're in the telephoto mode, instead of using some support. This may result in a soft image because of camera shake. To avoid soft or blurred images, a general rule of thumb is to use a shutter speed equal to or greater than the focal length of the lens. For example,

if you have a lens extension equivalent of 300 to 500 mm you should use a shutter speed of 1/500 of a second or higher. If you have to use a lower shutter speed then a brace such as a monopod or tripod may be necessary to obtain a sharp image.

Many prosumer cameras now have a vibration control setting. This can allow you to shoot at shutter speeds at least half of what is mentioned above and sometimes even less and still obtain a sharp image.

Most prosumer cameras do not take very sharp images above ISO-200-400. I recommend when using these cameras to use the lowest ISO possible. Keeping the camera on Aperture Control allows you to select the lowest f-stop which automatically gives you the highest shutter speed available and helps avoid soft images from camera movement.

Digital SLR's

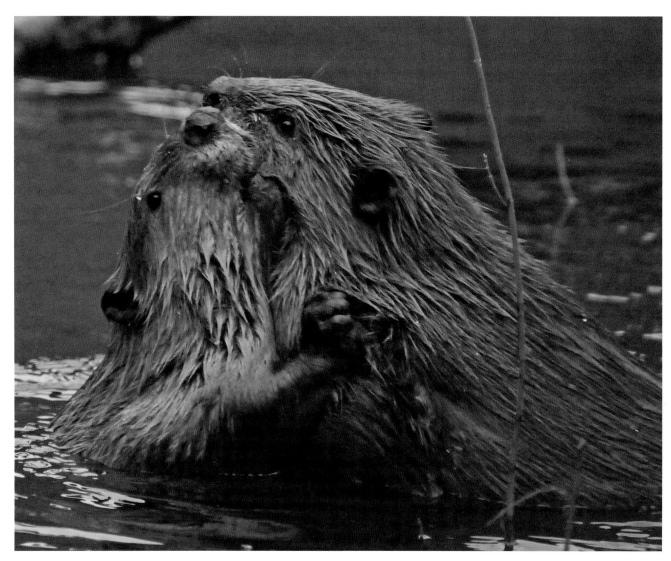

Nikon D-300, AF-S Nikkor 70-300mm lens, focal length 300mm, f/5.6 at 1/160 second, ISO equivalent 3200, 7/30/08, 6:28 a.m.

An adult beaver interacting with one of its yearlings. *I was quite happy with my prosumer digital camera until I needed to photograph beavers for a book a friend and I were writing. It was the rainiest summer on record, and the beavers were only out and about, for photography, between 5 and 7 a.m. – a really dark time of the day. My prosumer camera wouldn't deliver quality photos at much over ISO 200 which was way too little. I needed a camera that would produce good photos at a much higher ISO. I picked up an issue of Consumer Reports, which had an evaluation of Digital SLR's. One of their comparisons was the quality of photo produced at high ISO's. A few camera models did ok at ISO 1600, but at the time only one produced good quality photos at ISO 3200. That camera was the Nikon D-300, which had recently come out. So I purchased one. The camera worked great for beavers. Even at ISO 3200 I often had to shoot at 1/30 to 1/125 of a second shutter speed. But with the anti-shake mechanism turned on and by resting the camera on a log or branch I was able to obtain fairly sharp images.*

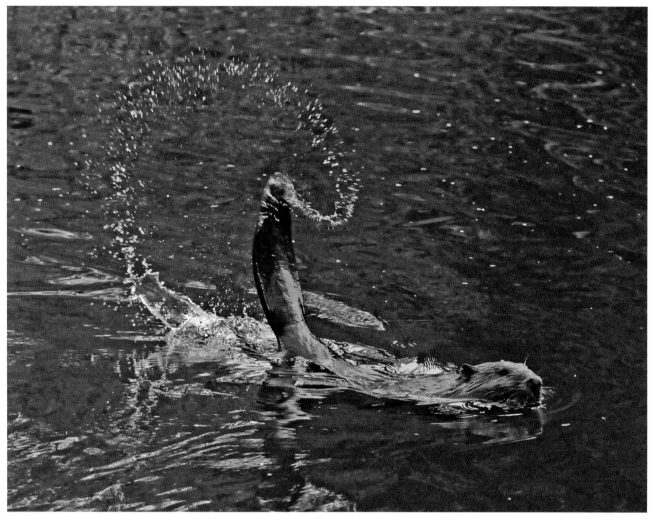

Nikon D-300, AF-S Nikkor 70-300mm lens, focal length 75mm, f/5 at 1/640 second, ISO equivalent 3200, minus .03 exposure compensation, 6/3/08.

Beaver with raised tail. *To get this photo I started the shutter in a continuous mode when I anticipated the beaver would slap its tail. This behavior happens so fast that it would be difficult to capture the moment as you saw it happening. Every time I waited until a beaver started to slap its tail, I got only the splash of water.*

Of course, having used a prosumer camera for so long, there were some things I did not like about the Nikon D-300. With a telephoto lens it was very heavy, and my neck got sore carrying it. I was used to no shutter noise and the D-300 made what seemed to me a big clank every time I pressed the shutter. In a continuous firing mode it sounded like a machine-gun to me. It was very frustrating to have subjects scared away or to stop what they were doing and look at me when I pressed the shutter.

Despite these shortcomings the camera had some real advantages for photographing wildlife. Since it did well at the higher ISO's that meant on bright days I could use a fast shutter speed for stopping action. Also, at the higher ISO's I could raise the f-stop for greater depth of field. That increased my chances of getting a sharp image of a bird in flight, for example. The D-300 also seemed to automatically focus much quicker than the prosumer cameras and could fire 6-8 frames per second, which also increased the chances of getting action photos.

High ISO's

In Juneau we often live under fairly dark and rainy conditions. If we waited for a sunny day we might not take a photo for a month or two. Also, in general, I have found that wildlife are often more active on cloudy days and you don't have the harsh shadows that sunlight tends to produce. Having a camera that does ok at the higher ISO's allows me to photograph under almost all weather conditions and not miss that once-in-a-lifetime photo because I was reluctant to wander about in inclement weather.

Another advantage of the higher ISO's is that they allow you to use high shutter speeds on the brighter days. This is a great advantage for action photos. Birds in flight, and creatures running, fighting, and chasing prey are much easier to photograph using the higher shutter speeds. When I anticipate an action photo I often choose an ISO that will give me around 1/4000 to 1/8000 of a second shutter speed. This speed is capable of stopping almost all things happening in nature, including the fast beating wings of a hummingbird.

Using a high ISO also allows you to use a higher f-stop for greater depth of field. When taking action photos you then have a greater chance that your subject will be in focus. On fairly bright days I usually set an ISO that will allow me to use f/8 and a fairly high shutter speed. Then when I am wandering about when something happens all of a sudden I have a greater chance of capturing the image.

What is ISO?

ISO sensitivity expresses the speed of photographic negative materials (formerly expressed as ASA). Since digital cameras do not use film but use image sensors instead, the ISO equivalent is usually given.

What ISO denotes is how sensitive the image sensor is to the amount of light present. The higher the ISO, the more sensitive the image sensor and therefore the possibility to take pictures in low-light situations. In general, (depending on how good the camera is) the higher the ISO, the more 'grainy' the picture looks. However, some of the high-end DSLR's produce very nice photos at the higher ISO's.

Auto Focus

Compared to my prosumer cameras the DSLR focuses much more quickly. For most wildlife, especially birds, I use the spot focus. For example, a warbler flitting about amongst the foliage is much easier to get in focus if you are using only the spot focus. The Nikon D-300 seems to excel in this regard. Also, if I use the continuous focus option, the camera seems to lock on and stay with flying birds even when they are coming toward me. With my prosumer camera I would occasionally do ok on birds in flight but had to take lots of photos. With the DSLR most of the photos I take of flying birds are at least in focus. There are still focusing problems with certain backgrounds and small birds, so taking lots of photos under certain conditions usually means at least some will be ok.

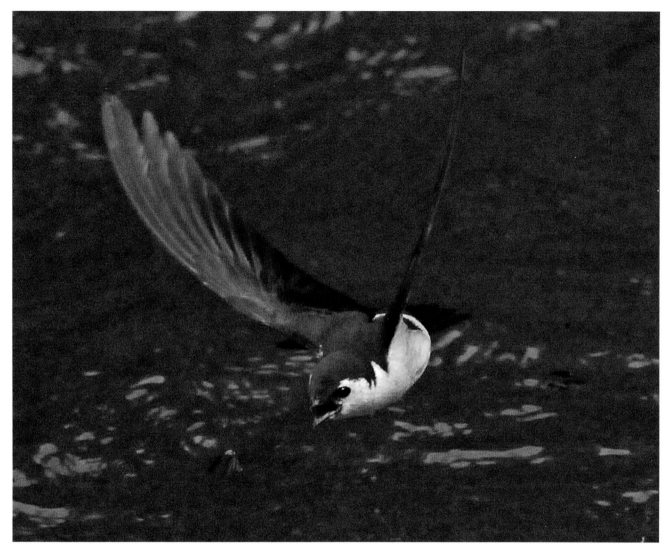

Nikon D-300, AF-S Nikkor 70-300mm lens, focal length 300mm, f/8 at 1/6400 second, ISO equivalent 3200.

Frames per Second

DSLR's usually can fire their shutters at a rapid rate (6-8 times per second). For fast moving subjects this increases the chances of getting that "perfect" image. Many things in nature happen too fast to focus on once you see them. So, in anticipation I often start firing the shutter before I see the image I want.

Violet-green Swallow about to capture an insect. *This is an example of how a high ISO, which allowed a high shutter speed and fairly high f-stop, worked to stop the bird and insect in flight. I was quite pleased by how the lens auto focus locked in on the swallow when it was coming towards me.*

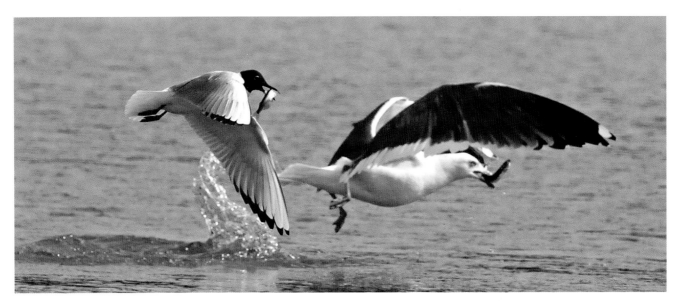

Nikon D-300, AF-S Nikkor 70-300mm lens, focal length 300mm, f/8 at 1/8000 second, ISO equivalent 1000, minus 0.7 exposure compensation, 5/4/09.

Lesser Black-backed Gull and Bonaparte's Gull with capelin. *The Lesser Black-backed Gull comes from Asia and is a very rare gull in Alaska. So it was quite a thrill for me to capture it in action. Ironically, it happened so fast that at the time I did not realize what the bird was. To also capture an adult Bonaparte's Gull with it was a bonus. A high shutter speed and f-stop helped make it happen.*

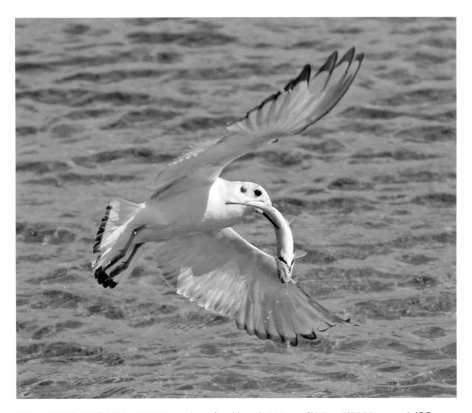

Bonaparte's Gull with Dolly Varden. *These gulls were diving after fish that I could not identify, so getting a photo to peruse really helped. It was a sunny day, so I used only enough ISO to get a shutter speed fast enough to stop the action.*

Nikon D-300, AF-S Nikkor 70-300mm lens, focal length 125mm, f/6.3 at 1/5000 second, ISO equivalent 800, no exposure compensation, 6/7/08.

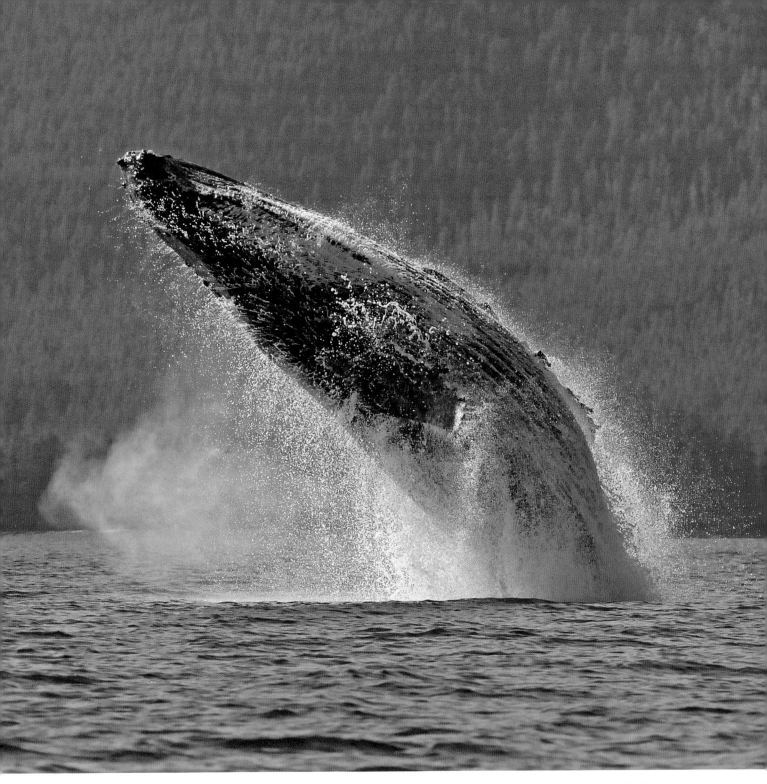

Nikon D-300, AF-S Nikkor 70-300mm lens, focal length 210mm, f/7.1 at 1/8000 second, ISO equivalent 1600, manual exposure, 9/14/09.

Humpback whale breaching. *To get a photo of a humpback whale breaching, at just the right moment when most of it was out of the water, I pressed the shutter before the whale leaped. I have not had many opportunities to photograph breaching whales, but this one was very cooperative. I could tell when it was going to breach because of the way it dove. I figured if I was looking in the right spot, once the whale started to breach I would focus on the area and press the shutter for continuous firing. The area was backlit so I determined the exposure with a hand-held incident light meter (see photo tips). A combination of correct exposure, rapid shutter firing, and a very fast shutter speed helped to make good images.*

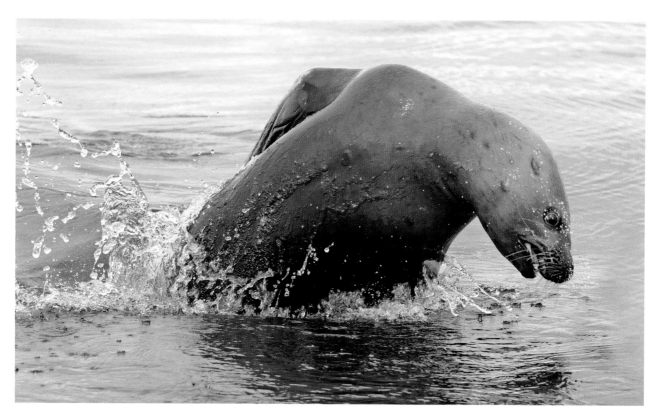

Nikon D-300, AF-S Nikkor 70-300mm lens, focal length 92mm, f/5.6 at 1/2000 second, ISO equivalent 800, manual exposure.

Steller sea lion. *While I was traveling along in a skiff this sea lion repeatedly leaped out of the water behind the boat. When I focused the camera behind the boat and held down the shutter release, it was fairly easy to capture the animal out of the water.*

Pink salmon leaping.
Jumping salmon are easier to photograph than I thought they would be. Certain individuals jump more than once and usually in a predictable direction. So once the fish jumped, by focusing ahead and starting to fire the shutter in a continuous mode, I had a fairly high probability of capturing it in mid-air and in focus.

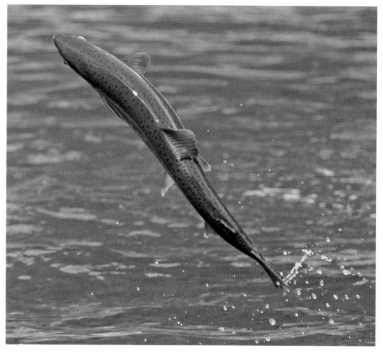

Nikon D-300, AF-S Nikkor 70-300mm lens, focal length 135mm, f/8 at 1/1250 second, ISO equivalent 1600, manual exposure.

Flash Synchronization with Natural Light

With the Nikon D-300 you can flash sync at any shutter speed (as long as you turn that feature on in the menu). If you use a high enough shutter speed you can get great action photos at fairly close range. This avoids the ghosting problems that I had with 35 mm cameras that would only flash sync at the lower shutter speeds. Previously in those conditions I always had to overcome natural light with the electronic flash and use an artificial backdrop to prevent the background from turning dark or black.

The Nikon Speedlight SB-800 set in the camera's hot shoe seems to work just fine. I usually set the flash and camera on manual. Here are three photos taken with this method at my bird feeder.

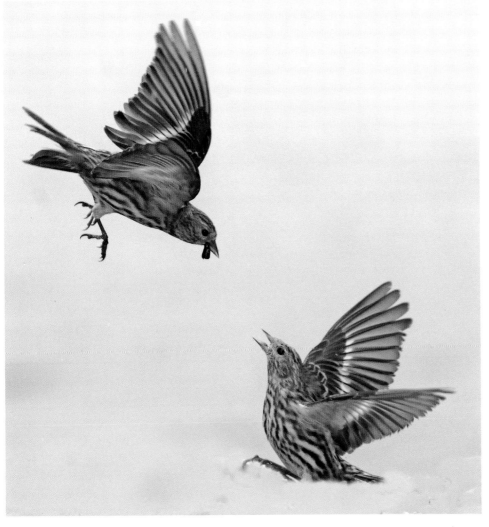

Pine Siskins interacting.
This is an example of coordinating the electronic flash with natural light.

Nikon D-300, Tamron AF 17-50mm 2.8 lens, focal length 50mm, f/5.6 at 1/2000 second, ISO equivalent 3200, manual exposure, Nikon Speedlight SB-800 set at 1/16 power.

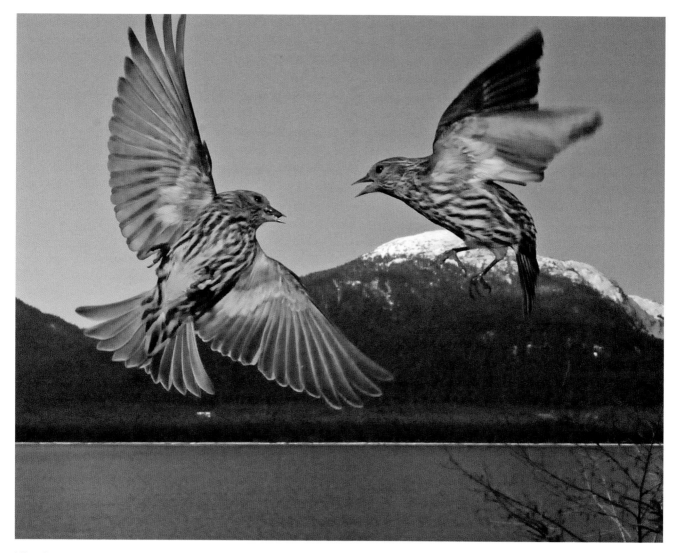

Nikon D-300, Tamron AF 17-50mm 2.8 lens, focal length 17mm, f/20 at 1/4000 second, ISO equivalent 3200, manual exposure, Nikon Speedlight SB-800 set at 1/16 power.

Pine Siskins fighting. *This is a good example of coordinating the light from the electronic flash with natural light allowing the mountains to show in the background.*

Red squirrel and Pine Siskin. *This is one of those photos that happen by accident. I was taking photos of the squirrel when this Pine Siskin landed on its back. Since I had the camera continuously firing, it captured the incident.*

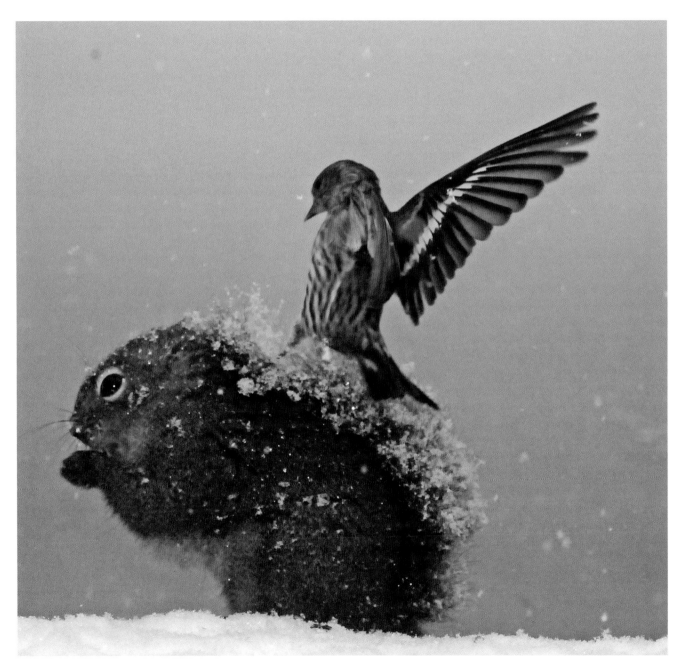

Nikon D-300, Tamron AF 17-50mm 2.8 lens, focal length 50mm, f/11 at 1/2000 second, ISO equivalent 3200, manual exposure, Nikon Speedlight SB-800 set at 1/16 power.

DSLR Photo Tips

Opportunities to capture wildlife in action often happen when you least expect it. Whenever possible I recommend carrying your camera ready (*i.e.,* even turned on) and setting all of the controls for action. Most important is a high shutter speed, next a fairly high f-stop for greater depth-of-field. Both of these can usually be accomplished by using a high ISO. For most action I usually set the Nikon D-300 at ISO 3200. I also usually set the camera in the continuous focus mode, especially if I am expecting birds in flight. Initially the best photo is usually obtained with a high shutter speed. If you get further opportunities for action photos of the same creature, and if the conditions allow, you can lower the ISO to obtain better quality photos with less noise.

Obtaining the correct exposure when shooting action can be a problem. If you use the camera's meter (which reads reflective light) it may give you an exposure for the background, which could be wrong. What's best is to measure the light falling on the subject. This can be achieved by using a hand-held flash meter. While these devices are normally used to record the light coming from electronic flashes, they are also great for measuring the natural light falling on a subject. I use the lightweight Sekonic Flash Master L-358. Beware of some of the older meters as they are not set up to work with the higher ISO's of the DSLR cameras.

Once you have determined the proper exposure for the light falling on your subject then you may want to make a couple of further adjustments. If your subject is very light (*i.e.,* white or yellow) you should close (raise) your f-stop perhaps by as much as one stop. If your subject is dark (*i.e.,* dark brown or black) then do the opposite by opening the lens for more light by lowering your f-stop. Subjects that are both dark and white can be somewhat difficult. Usually I

Sekonic Flash Master L-358

expose so that the white does not get bleached out but there is still enough light to bring out the darker details in Photoshop later. Adult Bald Eagles are a prime example of this.

Once you get used to using an incident meter all of the above can be determined very fast with just a click of the meter. Then I recommend setting the camera to manual and adjusting the shutter speed and f-stop accordingly. This seems to be especially important when shooting over water. Bright and dark reflections on the water often give erroneous settings when you're using the meter in the camera.

Another method of determining a correct exposure is to take a reading with your camera's meter off a somewhat neutral gray object (Some photographers even carry a neutral gray card with them.), and then set the shutter speed and f-stop in the manual mode and adjust the f-stop for dark and light subjects.

Special Techniques

Digiscoping

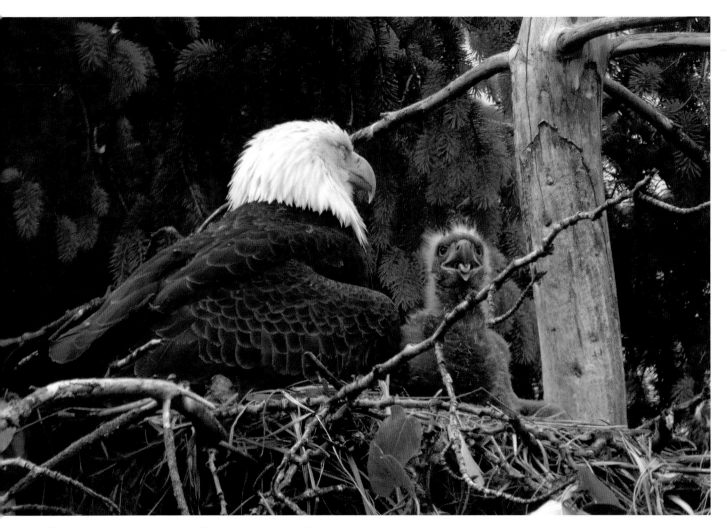

Fujifilm FinePix 4700, Kowa scope with 20 power objective, f/2.8 at 1/74 second, ISO equivalent 200, minus 0.9 exposure compensation, from a calculated 231 feet away.

Bald Eagle with young. *This was one of my first experiences with digiscoping. I was quite pleased to be able to photograph the nest full-frame from so far away. I especially liked the scene of the parent taking a snooze with the very alert youngster nearby.*

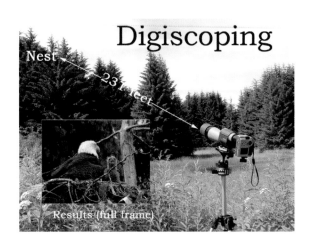

Digiscoping is taking photos using a small digital camera mounted on a spotting scope. This setup can easily give you a lens equivalent of about 2,300 mm. That's a very high magnification when you consider the biggest telephoto lenses for regular cameras are usually smaller than 1,000 mm and generally around 400 – 600 mm. Also, digiscoping equipment costs much less than high-quality large telephoto lenses and often weighs much less.

Digiscoping allows you to photograph most wildlife from a considerable distance without disturbing them. From 40 feet away you can get close-up photos of songbirds. You can be more than 200 feet away for larger birds such as Great Blue Herons and Bald Eagles. And you can be much farther away for large mammals such as mountain goats and bears.

Some say the quality of photos produced this way are not very good, but I disagree. Many of the photographs used in my *Guide to the Birds of Alaska* and other publications were taken through a spotting scope. I believe you can see very little difference when you compare the digiscoped photos with those taken with high end cameras and lenses.

The biggest selling point for me, however, is that I have been able to take photographs by digiscoping that I would not have been able to take, or that would have been much more difficult to take, using traditional photo equipment. For example, I was able to take full-frame photos of Bald Eagles at their nest from 230 feet away, and I photographed mountain goats full-frame without risking life and limb trying to climb close to them. I especially enjoy the way digiscoping allows me to photograph birds at their nests without disturbing them.

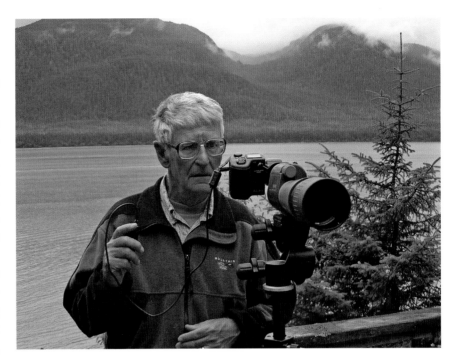

Digiscoping: Photo tips

Choosing a digital camera, tripod, tripod head, spotting scope, and other accessories can be very confusing. There is such a myriad of cameras and accessories to choose from. Many brands will work just fine, while others have considerable limitations for digiscoping.

I do not know all the advantages and disadvantages of the different camera models and accessories. But I have researched it enough to have a good idea of what works and what doesn't. The best I can do is tell you what has worked for me.

Camera – I now use the Samsung V70 digital camera and have also successfully used the Nikon Coolpix 995 digital camera. (Some people seem to have trouble digiscoping with the newer model 4500. I'm not sure why, but perhaps it is related to having a higher magnification 4x vs. 3x). Using the remote release device sold for the camera is almost a must.

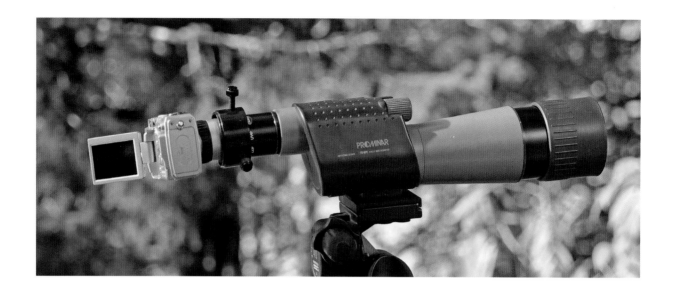

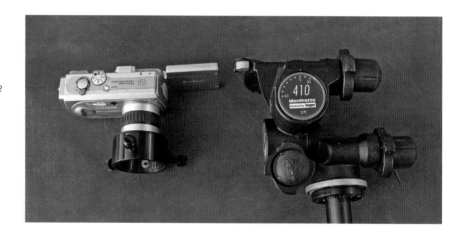

The top photo shows the entire digiscoping setup. The lower photo shows the camera and attachment device for the spotting scope and the geared head for the tripod.

Tripod – I now use mostly the Hakuba HG-6240C carbon tripod because it is light and sturdy and also the legs spread far apart for work near ground level. The type of head seems to be very important when digiscoping. I have tried and not liked any of the pan and tilt or ball heads (even the expensive ARCA Swiss monoball). The best head I have found is the Manfrotto 410 Junior Geared Head with a quick release plate. I use two heads – one on the tripod and one on a Bogen window mount that I always keep in the car. When you're digiscoping, the right type of tripod head is very important. The geared head allows for precise adjustments.

Scope – I use the Kowa Prominar TS-614 spotting scope with a 20-power wide-angle objective. The Kowa scope is one of the lightest sold (1.7 lbs), which is the main reason I chose it. The cloth cover that you can purchase with the scope helps protect it and is easy to use in the field. I would avoid the variable power objectives and any of the fixed objectives above 20 power. I found even the 25-power objective difficult to use. It had too much magnification.

Attachment – I use the LE – Adapter sold by Lens Plus at www.lensadapter.com

Operation hints – When digiscoping I use the aperture priority mode and the lowest f-stop I can. I use manual focus set at 30 feet and

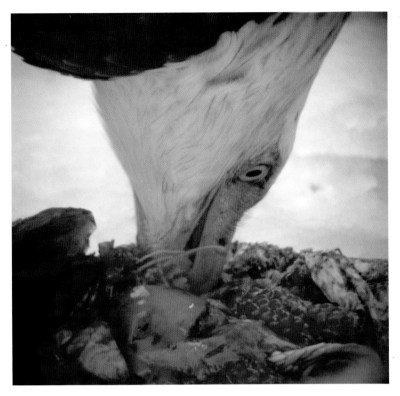

Digiscoped, Nikon E995, Kowa scope with 20 power objective, f/4.5 at 1/60 second, from about 100 feet away.

Bald Eagle feeding on salmon eggs and Bald Eagle staring into the mouth of a salmon. *Once I used digiscoping at the Chilkat Bald Eagle Preserve near Haines, Alaska. I felt a little ridiculous standing next to other photographers with their huge telephoto lenses and massive tripods. But while they were concentrating on getting perfect full-eagle photos I was concentrating on just the birds' heads. Focusing on an eagle's head plunging into bright red salmon eggs or looking down into the mouth of a salmon showed me different aspects of eagle behavior that I had not photographed before.*

focus with the scope. To obtain a high quality photo the camera must be perfectly still. It's best to be out of the wind and to not touch the camera at the moment of exposure. Remote release or use of the self-timer is very important.

Digiscoping update – Swarovski scopes have come out with an adapter which should allow you to use almost any prosumer digital camera. It's called the Swarovski DCB-S Non-SLR Digiscoping/Viewing Flip-Away Bracket. Some general hints: Do not choose a camera that goes beyond 3x. Try to find one that has a remote release either by cable or wireless. A movable LCD screen helps with digiscoping.

Final note – If you are far-sighted you may have trouble focusing the camera. If you are seriously considering getting into digiscoping I suggest you try it first with someone who has a setup before you purchase equipment.

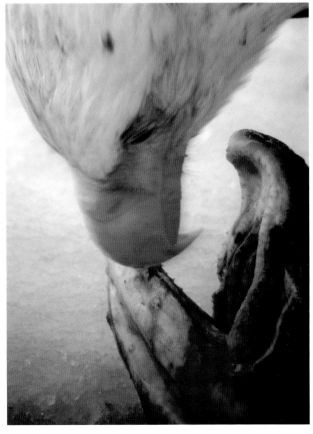

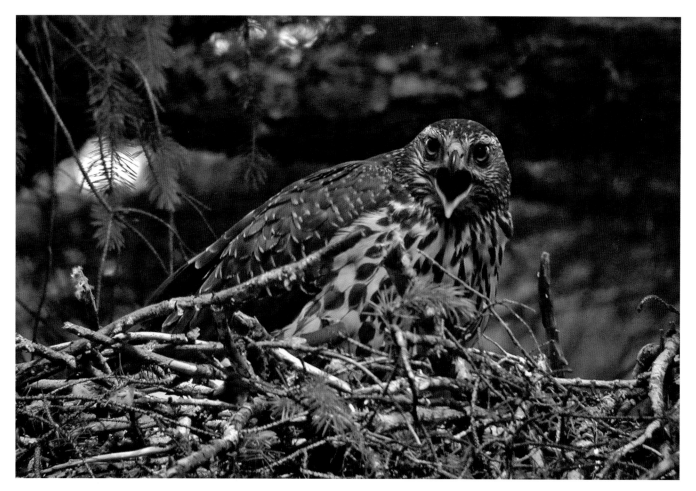

Digiscoped. Nikon E995, Kowa scope with 20 power objective, f/4 at 1/26 second, ISO equivalent 100, minus 1 exposure compensation, from about 200 feet away.

Northern Goshawk female at nest. Being far from your subject does not guarantee an easy time. Once I was photographing Northern Goshawks at their nest from more than 200 feet away with digiscoping equipment. Suddenly without any warning the female goshawk hit me on the side of my head. As I hurriedly gathered up my equipment to leave, it hit me again on the back of my head. Fortunately, the bird seemed to be striking with closed talons. I later heard that other people had not been so lucky; they'd actually had their scalps opened up by the same bird. Nevertheless, my head hurt for about a week, and I suppose I deserved it.

Only a small percentage of female goshawks nest so young that they are still in their immature plumage. This made the photo even more special to me.

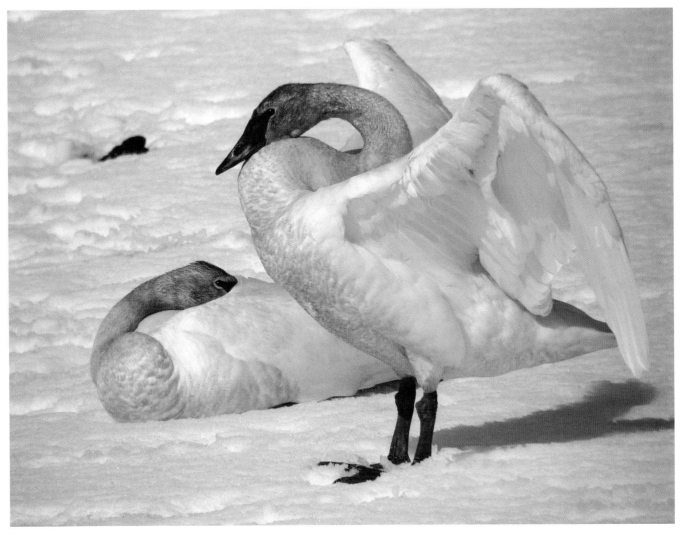

Digiscoped. Samsung Digimax V70/a7, Kowa scope with 20 power objective, f/4.9 at 1/2000 second, ISO equivalent 100, minus 0.5 exposure compensation, from about 200 feet away.

Trumpeter Swans on snow. *I spent several hours photographing these swans from a bridge where they were not disturbed by my presence. On several occasions I would see photographers try to approach the swans along the river, causing the birds to flush. The usefulness of digiscoping was quite evident here.*

Mountain Goat feeding.

These two photos illustrate what the same mountain goat looks like photographed with a 420 mm lens equivalent as compared to digiscoping with a 2,300 mm equivalent. Both photos were taken from the same spot and are presented here without any cropping.

Panasonic DMC-FZ30, f/7.1 at 1/1,000 second, ISO equivalent 100, 420mm equivalent, from about 300 feet away.

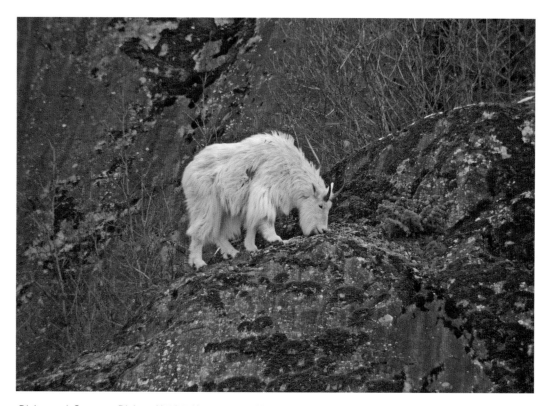

Digiscoped. Samsung Digimax V70/a7, Kowa scope with 20 power objective, f/4.9 at 1/180 second, ISO equivalent 100, minus 0.5 exposure compensation, from about 300 feet away.

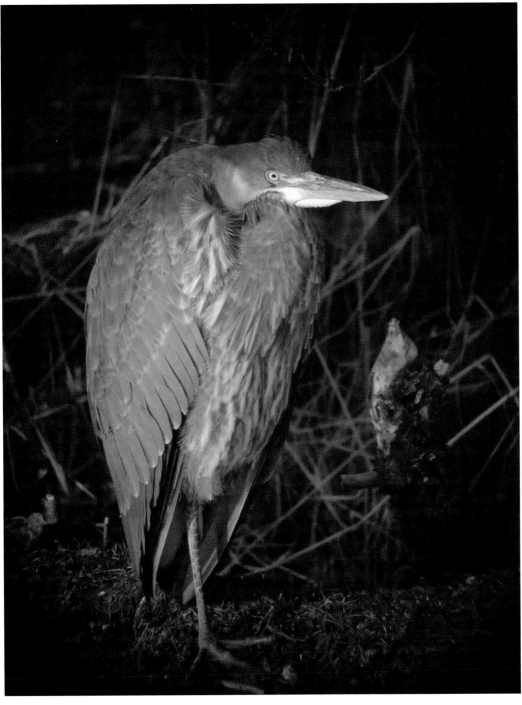

Great Blue Heron. I was driving along the road near the Juneau Airport when I spotted this heron resting near Jordan Creek. It made an interesting scene with a shaft of sunlight and a beaver-chewed stump next to it. I drove around the block and parked on the opposite side of the street and took this photo with digiscoping equipment from the car. The heron gave no indication that it was concerned about my presence. Numerous cars were zooming past, and the wind from each one jiggled my car so much that any photos I took when cars were passing came out blurry.

Digiscoped. Samsung Digimax V70/a7, Kowa scope with 20 power objective, f/6.7 at 1/90 second, ISO equivalent 100, from about 200 feet away.

Lincoln's Sparrow on Nootka lupine.

During nesting season, ground nesting sparrows usually perch on top of vegetation to keep an eye on anyone passing nearby. However, if you approach them to get photographs they usually drop out of sight. Digiscoping allowed me to get this photo without causing the bird to flush. To get full-frame images of small birds the size of sparrows with typical telephoto lenses of about 400mm requires you to be about 8 to 10 feet from your subject. This usually brings you too close to these birds and can be disruptive of their normal behavior. Digiscoping allows you to stay much farther away, usually outside their range of normal concern.

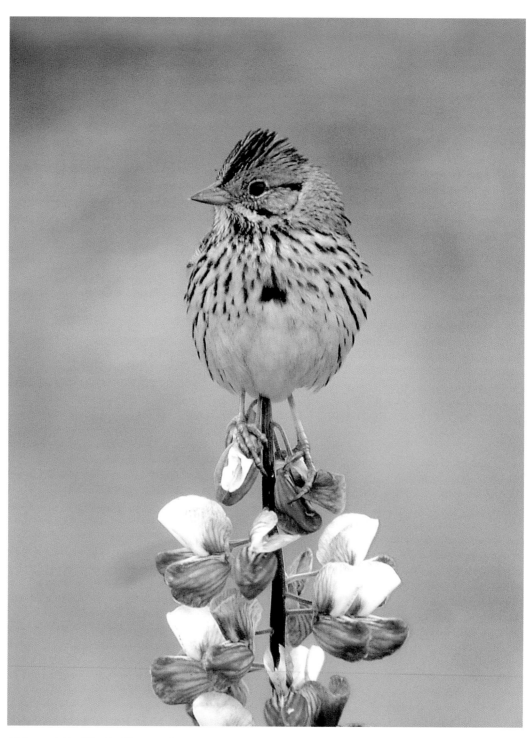

Digiscoped, FugiFilm FinePix 4700, Kowa scope with 20 power objective, f/2.8 at 1/32 second, ISO equivalent 200, minus 0.6 exposure compensation, from about 40 feet away.

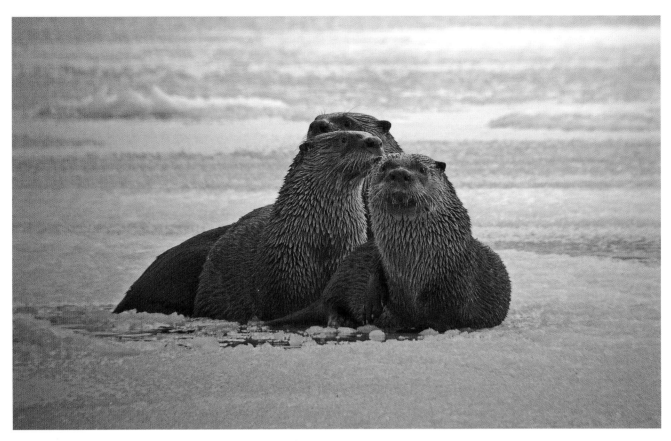

Digiscoped. Samsung Digimax V70/a7, Kowa scope with 20 power objective, f/6.7 at 1/90 second, ISO equivalent 100, from about 200 feet away.

River otters. River otters seem to be quite wary of humans. Although I was about 200 feet away, the animals in both these photos still were aware of my presence. The three in the top photo seemed concerned, but the one in the lower photo kept feeding. Digiscoping allowed me to get at least a few portraits of these beautiful animals, and I could even tell what species of fish the otter in the lower photo was eating (starry flounder).

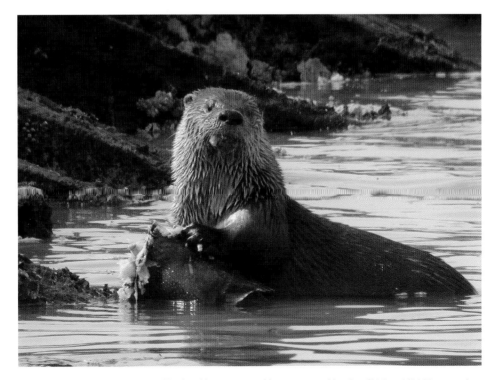

Digiscoped. Samsung Digimax V70/a7, Kowa scope with 20 power objective, f/4.9 at 1/2000 second, ISO equivalent 200, minus 1.5 exposure compensation, from about 200 feet away.

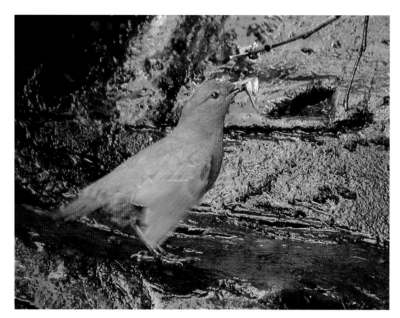

American Dipper with salmon fry. *This dipper was bringing salmon fry and aquatic insects to its young at a nest. Without digiscoping this photo would have been very difficult to take because you could only see the nest from a considerable distance away. I was very pleased to get this photo because recent research suggests that salmon fry are important for the successful raising of dipper chicks.*

Digiscoped, Nikon Coolpix E995, Kowa scope with 20 power objective, f/3.7 at 1/22 second, ISO equivalent 100, minus 1 exposure compensation, from about 50 feet away.

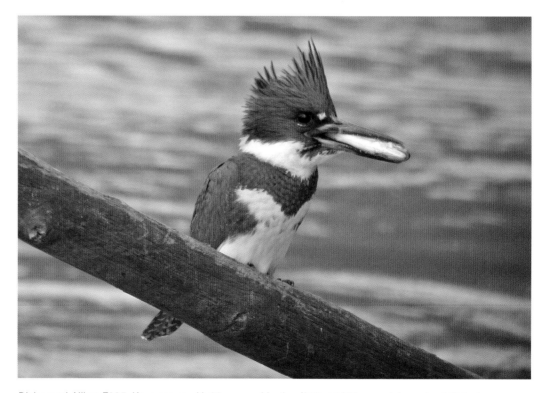

Digiscoped, Nikon E995, Kowa scope with 20 power objective, f/4.5 at 1/60 second, from about 50 feet away.

Belted Kingfisher female with salmon young. *Before bringing fish to their young these kingfishers would perch on a log near the nest. By sitting in the tall grass and using digiscoping equipment I was shielded enough and far enough away that the birds pretty much ignored me. The perching log, however, was embedded into the stream bottom, and the current caused it to bounce up and down. That made it difficult to get a clear image at the low shutter speed required for the low-light conditions.*

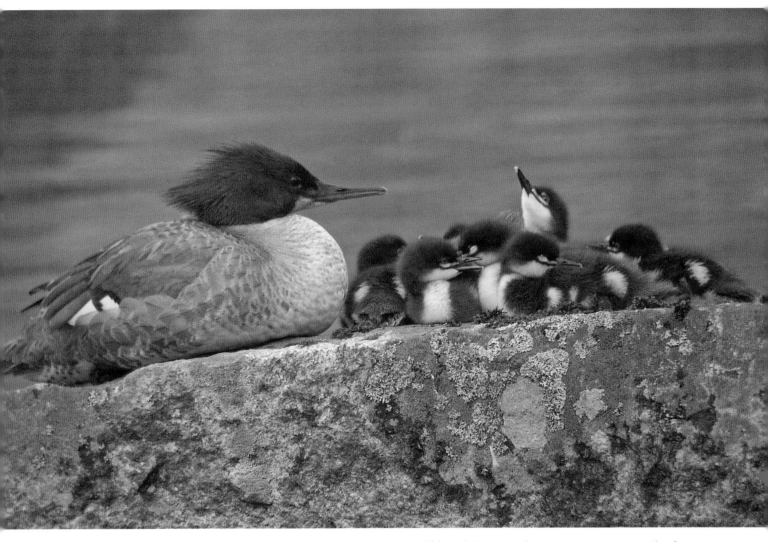

Samsung Digimax V70/a7, Kowa scope with 20 power objective, f/4.9 at 1/250 second, ISO equivalent 100, minus 0.5 exposure compensation, from about 100 feet away.

Common Merganser with young. *When I saw this merganser family resting on a rock, I approached slowly, just until the mother indicated she was aware of my presence. After I stood still for a few minutes, she fell asleep and I was able to take several photos, then leave without disturbing them. That's always a good feeling.*

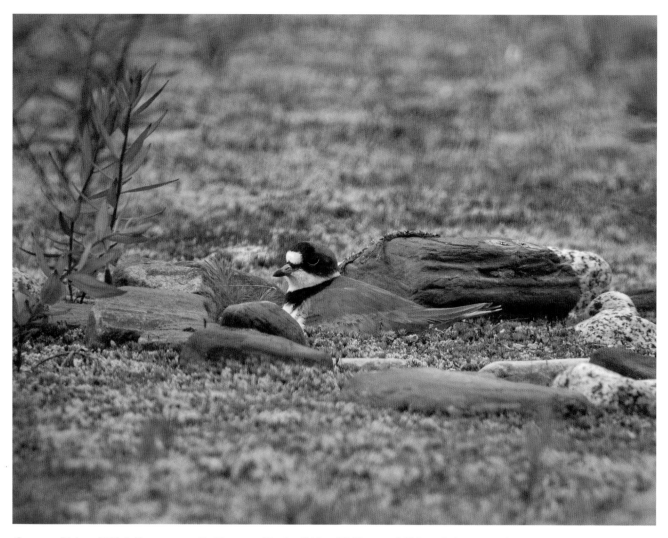

Samsung Digimax V70/a7, Kowa scope with 20 power objective, f/4.9 at 1/250 second, ISO equivalent 100, minus 0.5 exposure compensation, from about 60 feet away.

Semipalmated Plover on nest. When I inadvertently stumbled onto this plover's nest, the bird immediately went into the typical "broken-wing" act. I backed away from the nest and the bird returned fairly quickly, but without digiscoping or remote triggering devices I probably would not have been able to get this photo.

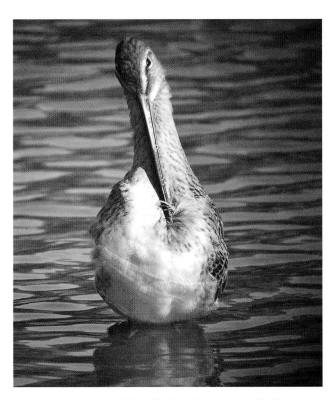

Dowitcher preening. I really enjoy watching and photographing shorebirds from a distance. When they're preening and bathing they can get into some almost humorous positions, especially the long-billed ones.

Digiscoped. Samsung Digimax V70/a7, Kowa scope with 20 power objective, f/4.9 at 1/2000 second, ISO equivalent 200, minus 1.5 exposure compensation, from about 40 feet away.

Greater Yellowlegs bathing. Here's another shorebird that got wrapped up into an almost comical position. This one had just finished bathing and rubbed its head on its wing before flying off.

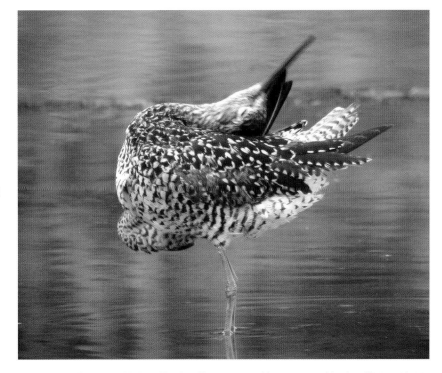

Digiscoped. Samsung Digimax V70/a7, Kowa scope with 20 power objective, f/4.9 at 1/2000 second, ISO equivalent 200, minus 1.5 exposure compensation, from 40 feet away.

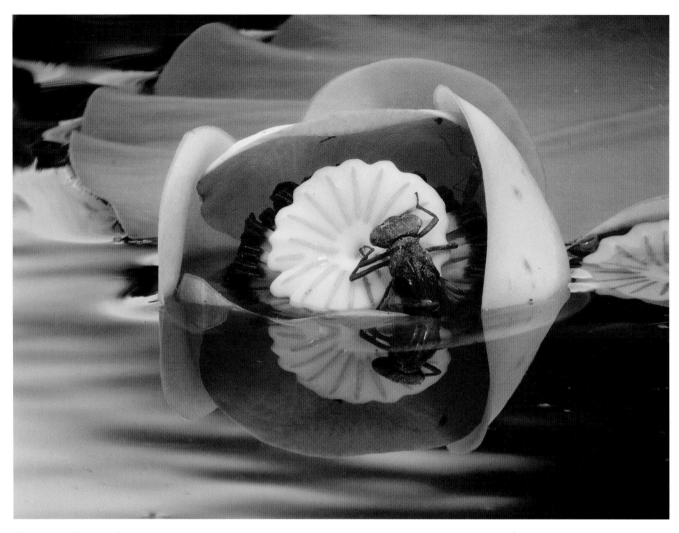

Digiscoped. Samsung Digimax V70/a7, Kowa scope with 20 power objective, f/6.7 at 1/90 second, ISO equivalent 100, from about 25 feet away.

Dragonfly larva on pond lily. Digiscoping can also be used to photograph insects and flowers that are too difficult to get close to. For example, when dragonfly larvae are just emerging to change into adults, any disturbance will usually cause them to retreat back into the water. Digiscoping allowed me to take this photo full frame without disturbing the insect. Since the larva also was in the middle of a pond, I would have had to go swimming to get close enough with conventional photo gear.

Supermacro

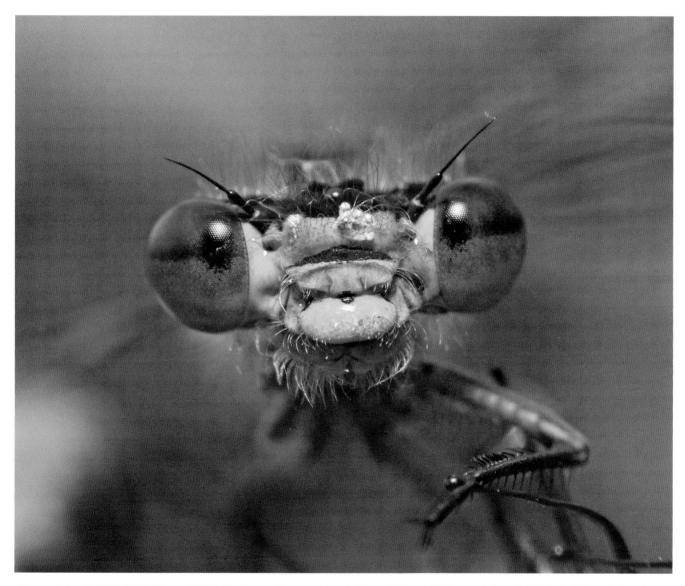

Panasonic Lumix DMC-FZ30, Raynox DCR-250 close-up lens, focal length 89mm, f/10 at 1/125 second, Sunpak 333 flash, ISO equivalent 100, tripod.

Damselfly eyes. *This damselfly photo is one I had always wanted but it seemed impossible to get. Most damselflies will not let you get close enough for just a head shot, or they are not perched at the right angle. Even cooling them down and then posing them usually will not work because they warm up too fast and fly away. On a trip to the Kanuti Wildlife Refuge in northern Alaska I found a damselfly stuck to some sundew plants. It, of course, had no choice but to stare at me and the camera while I took photos from 4 inches away. After the photo session I gently pried the insect away from the sundew and it flew away. I suspect the sundew plant was not happy, as the damselfly would have made a much bigger meal than the usual mosquito.*

A couple of years ago a friend sent me an article from the summer 2007 issue of *Nature Photographer*. It was by Bob Frank and was titled "Insect Photography: A New Way of Thinking." Frank used a Raynox DCR-250 achromatic close-up lens attached to a Panasonic FZ-30 camera.

The photos in the article were very good, I already owned a Panasonic FZ-30, and the price of the lens was only about $60. So I bought one. For best results Frank said the setup required an electronic flash mounted on the hot shoe and bounced off a piece of white cardboard attached to the flash.

I tried it, and the results were incredible. First off it gave a much higher magnification than most macro lenses which, without extension tubes, would only go down to a 1 to 1 ratio. Secondly, typical macro lenses require you to be quite close to small subjects such as most insects. But with the Raynox lens you always focused from about 4 inches away from your subject, regardless of the lens extension. This meant that you usually didn't scare your subject away and that you could zoom in to find the subject then zoom out or much closer without changing the distance. In other words you can full-frame a mosquito from 4 inches away.

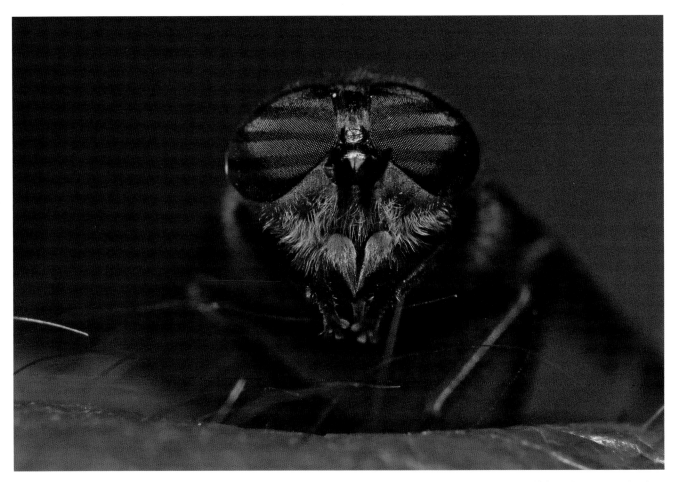

Panasonic Lumix DMC-FZ30, Raynox DCR-250 close-up lens, focal length 79mm, f/9 at 1/80 second, Sunpak 333 flash, ISO equivalent 100, tripod.

Horsefly eyes. *I cheated to get this photograph of the horsefly eyes. The insect was captured in a net and transferred to a portable cooler to slow down its metabolism. Once it had cooled down I posed it on the back of my hand. As it warmed up and returned to looking as if it was going to bite, I clicked the camera and chased it away.*

Panasonic Lumix DMC-FZ30, Raynox DCR-250 close-up lens, focal length 24mm, f/9 at 1/125 second, Sunpak 333 flash, ISO equivalent 80, monopod.

Another benefit is that the Panasonic will flash sync at any shutter speed. So when setting shutter speed and f-stop manually you can coordinate between natural light and flash. This means that illumination of your subject can look more natural without the harsh black backgrounds often created when using cameras that will only flash sync at certain shutter speeds.

Hoverfly on broad-petalled gentian. *I was quite excited to get this photograph because I have often wondered what pollinates these flowers. The broad-petalled gentian opens only in sunlight and is one of the latest blooming flowers in the alpine—often seen clear into September.*

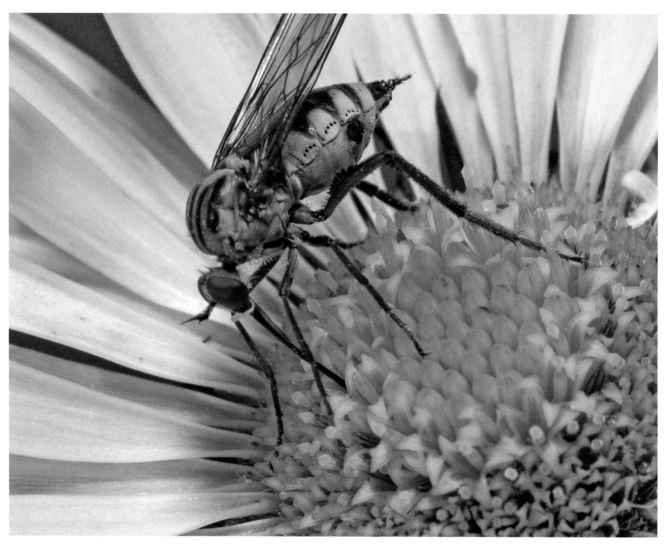

Panasonic Lumix DMC-FZ30, Raynox DCR-250 close-up lens, focal length 44mm, f/11 at 1/500 second, Sunpak 333 flash, ISO equivalent 80, monopod.

Dance Fly. I found this insect feeding on a daisy in the alpine. In mid- to late summer the alpine areas of Alaska can be great places to look for insects to photograph. Many of the flowers at lower elevations have gone past the blooming stages, and alpine flowers are usually in their prime.

Females and males in this genus feed on nectar at flowers, as the fly in the photo is doing. Males capture small flies and present them to females as a nuptial gift during elaborate courtship rituals. This gift of prey is the only protein source the female has for maturation of her eggs since she herself is unable to capture prey.

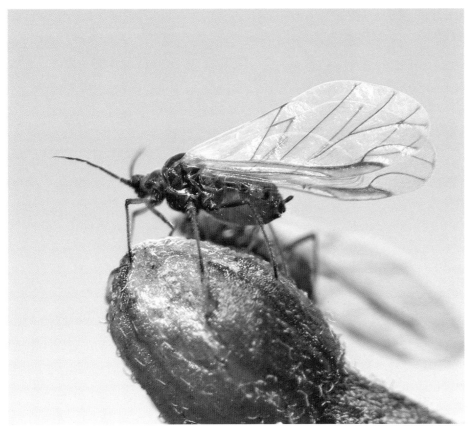

Panasonic DMC-FZ30, focal length 89 mm, f/9 at 1/100 second, ISO equivalent 100, manual exposure, Supermacro lens with electronic flash, 8/17/08.

Winged aphid on fireweed and Red ant on fireweed.

With the Supermacro lens you can photograph very tiny insects. These aphids and ants are only a few millimeters long and difficult to see with the unaided eye. See the story about them in the section on "connections."

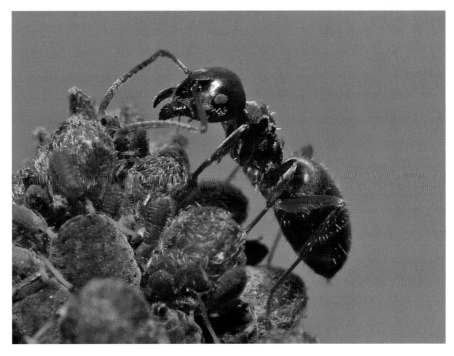

Panasonic DMC-FZ30, focal length 60 mm, f/10 at 1/200 second, ISO equivalent 80, manual exposure, Supermacro lens with electronic flash, 8/15/08.

Supermacro Photo Tips

Bob Frank's article suggests using a monopod for more versatility when using the supermacro lens. While I agree, I found it difficult to use because I have a certain amount of hand tremor and I had trouble holding the camera steady. I found that the best support for me was a tripod.

I believe the best electronic flashes for the hot shoe of the Panasonic Lumix FZ30 are those that will operate in a manual mode and have a power ratio control. With a little experience you learn the best starting exposure and can quickly adjust everything for a pleasing exposure between the flash and natural light.

I started out by using a piece of white

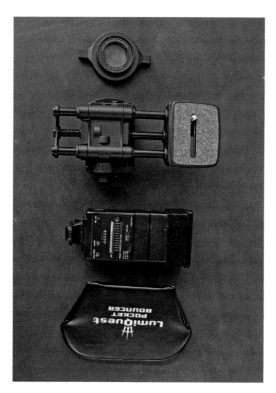

The Supermacro setup

Supermacro components. (Top to bottom) Raynox DCR-250 close-up lens, Velbon Super Mag Slider, Sunpak 333 electronic flash, LumiQuest Pocket Bouncer.

cardboard attached to the electronic flash in order to bounce the light onto the subject. This worked fine, but after considerable use the cardboard tends to fall apart. I eventually used a LumiQuest Pocket Bouncer attached to the flash and was quite pleased by its durability and packability.

For precise focusing, especially needed on very tiny subjects, I recommend using a Velbon Super Mag Slider. This allows you to make fine adjustments forward, backward, and sideways as your subject moves about.

Regular Macro

Both point-and-shoot and prosumer cameras, with their great depth of field, are wonderful for doing regular macro work. The beauty of them, with their small size and light weight, is that you can always have one of these cameras with you when you're out and about. If you come across something unusual happening, it's easy to snap a photo right on the spot.

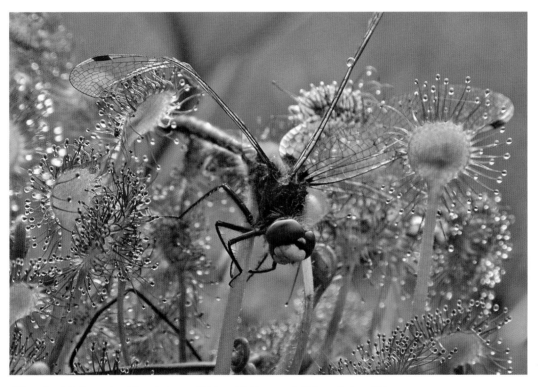

Hudsonian whiteface dragonfly caught in a sundew plant. *I came across this scene while on a very long hike. By always having the lightweight prosumer camera with me I was able to capture the dragonflies dilemma.*

Nikon Coolpix E995, focal length 24mm, f/4.9 at 1/316 second, ISO equivalent 100.

Dance fly on orchid. *This shows the wonderful macro capabilities of some point-and-shoot cameras. This insect is about the same size as a mosquito.*

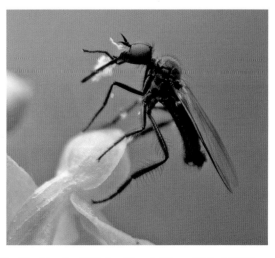

Fugifilm Fine Pix 4700, focal length 25mm, f/2.8 at 1/223 second, ISO equivalent 200.

49

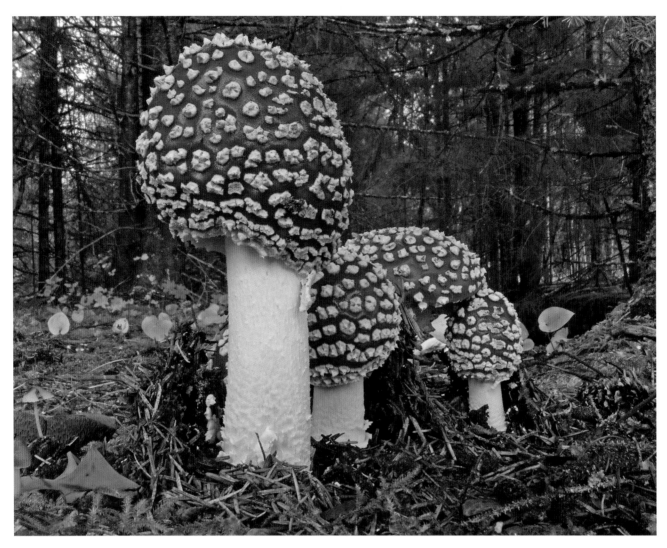

Panasonic DMC-FZ30, focal length 7mm, f/11 at 1/13 second, ISO equivalent 100, minus 0.7 exposure compensation, 9/26/2005.

Amanita mushroom. *I think these mushrooms are one of the most striking kinds in Alaska. This photo shows the good macro capabilites of a prosumer camera. The great depth of field makes all of the mushrooms sharp, even though they are situated in a row away from the camera. Also, the image brings in enough of the surroundings to identify their habitat. The camera was hand-held and the movable LCD screen was used to compose the photo.*

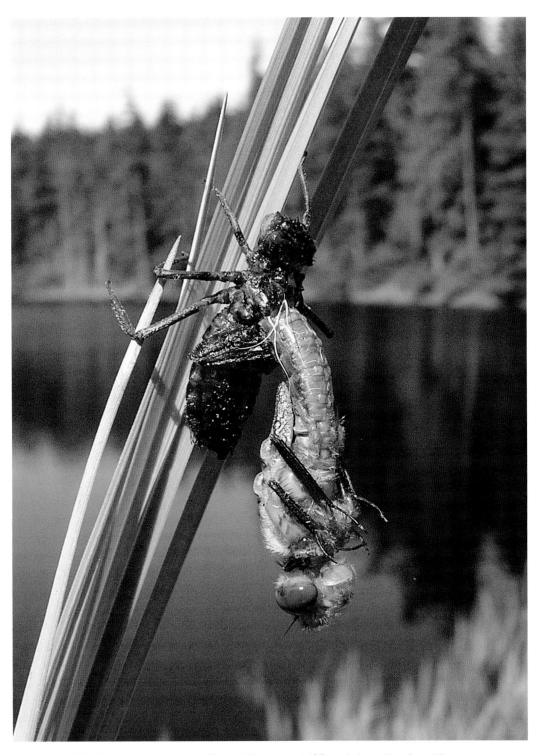

American Emerald dragonfly emerging. *A friend and I once took a fairly long hike that was not for the purpose of taking photographs. While passing a small lake we noticed American Emerald dragonflies were emerging from their exoskeletons--a very exciting event, and one I had not seen before. Fortunately, I had my small prosumer digital camera with me. We spent the next two hours watching and photographing the event. Once started, it took a dragonfly about one hour to emerge from its exoskeleton. Then it would rest for another hour while its wings hardened and before it could fly away.*

I was thrilled to be able to document the process with photographs and so glad I had remembered to put my easy-to-carry camera in the pack. I also liked the photos because, despite the close focusing required, the prosumer camera had enough depth of field to show the lake, placing the event in its natural setting.

Panasonic DMC-FZ10, focal length 6 mm, f/5.3 at 1/800 second, ISO equivalent 100, minus 0.7 exposure compensation, 5/19/04.

51

Remote Triggering Devices

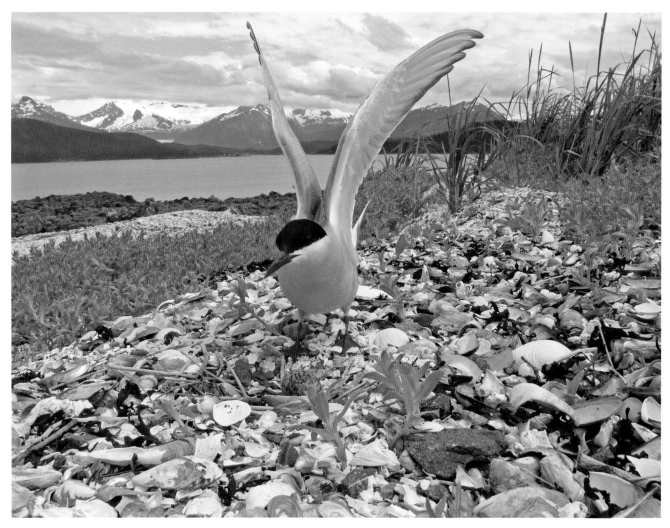

Panasonic DMC-FZ30, focal length 7mm, f/11 at 1/320 second, ISO equivalent 100, minus 0.7 exposure compensation, Dale Beam, 6/16/06.

Arctic Tern at nest. *This photo is a good example of when all things come together for a photograph. It was a sunny day so the terns were taking off and landing at regular intervals. Every time the bird took off or landed it broke the beam and triggered the camera. Using a prosumer camera at f/11 allowed for good depth of field to bring in the surrounding mountains. The shutter was silent so the bird was not alarmed when it triggered the equipment. I was very pleased with this photo because the egg was visible and the tern's wings were raised.*

Over the years I have used several different types of devices that enable you to trigger your camera at a distance. Some use an infrared beam, others are radio controlled, and one called the Dale Beam triggers the camera when a light beam is broken. These are wonderful devices. They are relatively small and light, and most will trigger the camera from about 200 feet away or more. One (the Dale Beam) can be set up so that your subject triggers the camera.

Remote triggering devices are especially useful for photographing birds at their nests. Birds seem to accept a camera near their nest very quickly, and from my experience, most return to the nest almost immediately after you leave the area. Some even use the camera or device as a perch before going to the nest. Overall, I believe a camera with a remote triggering device is accepted by nesting birds very quickly and is less intrusive than using a blind.

To operate I usually sit about 100 feet away and watch the target site with binoculars to determine the best time to trigger the camera. If I can't see the site I usually wait about 15 minutes and then trigger the camera at various intervals.

Devices for photographing remotely are also fun to use at your bird feeder. You can make natural looking perches or scenes to focus on, and the devices have no trouble activating your camera through window glass. This means you can take photographs from the comfort of your home.

The Dale Beam sends out an infrared beam to a small reflector (like a bicycle reflector) that

Nikon F3, 105mm Micro-Nikkor lens, Kodachrome 64, Nikon infrared triggering device.

Male Spotted Sandpiper on nest. *I liked this photo because the bird was nesting at the base of lupines. Female Spotted Sandpipers, after laying the egg, lure the male into doing all the incubation. This is quite unusual in the bird world.*

53

bounces the beam back to the device. When the beam is broken it triggers the camera. To use this device you don't even have to be around. Once it's set up, every time a bird visits the nest the beam triggers the camera. You can set it up so that even movement at the nest, such as a parent feeding young, will trigger the camera.

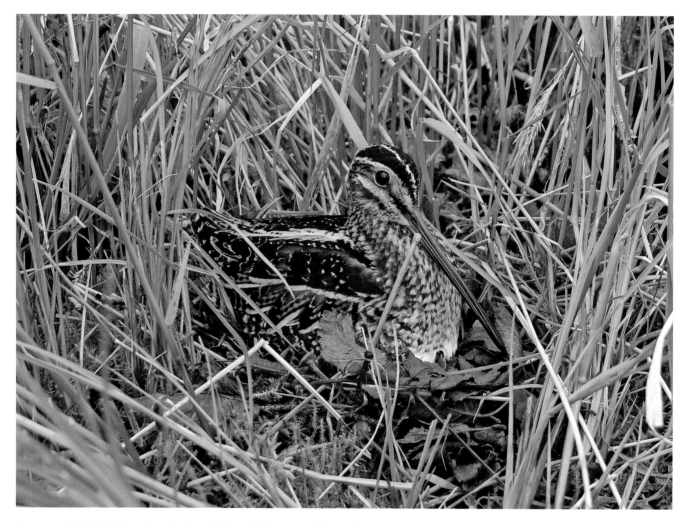

Panasonic DMC-FZ30, focal length 16 mm, f/3.6 at 1/100 second, ISO equivalent 100, minus 0.7 exposure compensation, Pocket Wizard Plus II triggering device, 6/6/07.

Wilson's Snipe on nest. *Getting a photograph of these elusive birds is not easy, but finding a nest and using a remote triggering device worked for me. Once I had the camera set up I left the area for about half an hour. I could not see the spot because of the tall grass, so when I was about 100 feet from the area I started triggering the Pocket Wizard. Of course when I got to the nest the bird flushed. Thanks to digital cameras I was able to see immediately that I had good photos of the bird. I then picked up the equipment and left the area.*

Nikon F3, 105mm Micro-Nikkor lens, Kodachrome 64, Dale Beam, electronic flashes.

Chestnut-backed Chickadee. *This was a set-up at my bird feeder. I put a snow-covered branch in front of the feeder so the birds had to fly over it to get to the feeder. Then I positioned the Dale Beam so that a flying bird would break the beam and trigger the camera. I used colored composition paper as a backdrop. I positioned electronic flashes on the area of focus and the backdrop, and determined their intensity by using a flash meter. One flash was attached to the camera; the others were on slave units.*

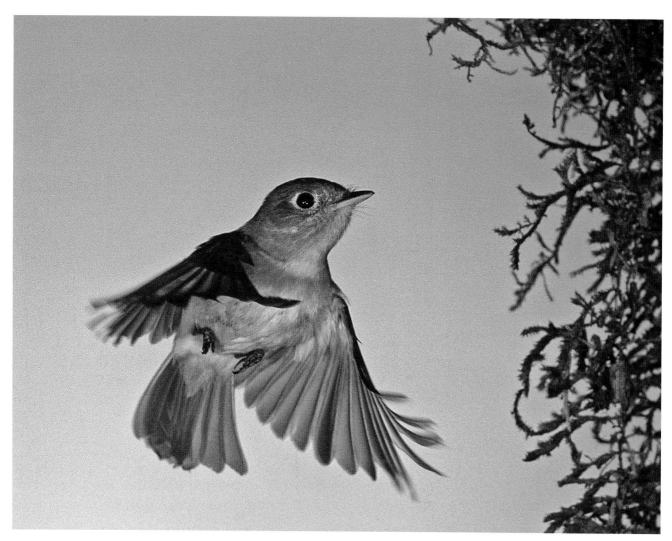

Nikon F3, 105mm Micro-Nikkor lens, Kodachrome 64, Dale Beam, electronic flashes.

Pacific-slope Flycatcher. *This bird nested on my back porch. I covered the nearby post with moss and put up a colored composition board as a backdrop. The Dale Beam was set up so that when the bird flew to its nest the camera was triggered.*

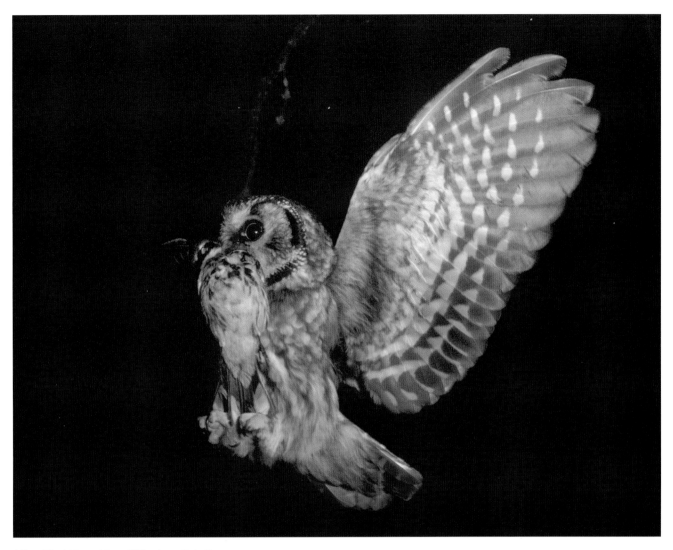

Nikon F3, 105mm Micro-Nikkor lens, Dale Beam,
Kodachrome 64, electronic flashes.

Boreal Owl. I found this nest in a fairly remote area near Fairbanks one winter. It was about 10 degrees below zero outside, so I used fresh batteries for the motor drive and flash units. I left the equipment out all night. When I picked it up in the morning all the batteries were dead, and in those days before digital cameras I had to wait a couple of weeks to see if I had any photographs. I worked with the nest for several weeks and was able to identify the different prey being brought in. In April the owls brought only small rodents, but by May they started bringing in birds such as this Yellow-rumped Warbler. When I was setting up the equipment during the day, the owl would watch me from its nest hole and sometimes fall asleep.

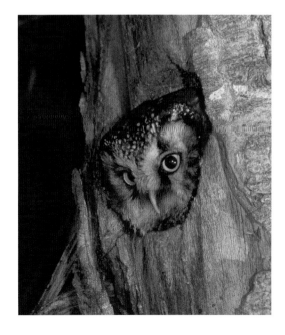

Northern flying squirrel. *For the last two years a flying squirrel has been coming to my bird feeder at night for a few peanuts. I put this log near the feeder and put a couple of peanuts on top of it. I used one electronic flash with a slave unit and triggered it with the camera's built-in flash. I triggered the camera remotely from my house using Pocket Wizards.*

Panasonic DMC-FZ30, focal length 75 mm, f/8 at 1/80 second, ISO equivalent 100, electronic flash, Pocket Wizard Plus II triggering device.

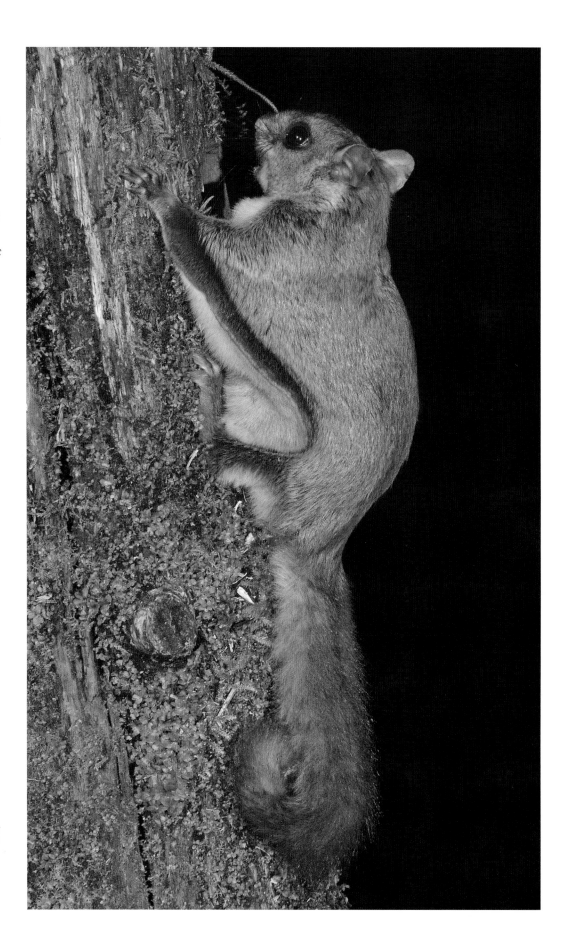

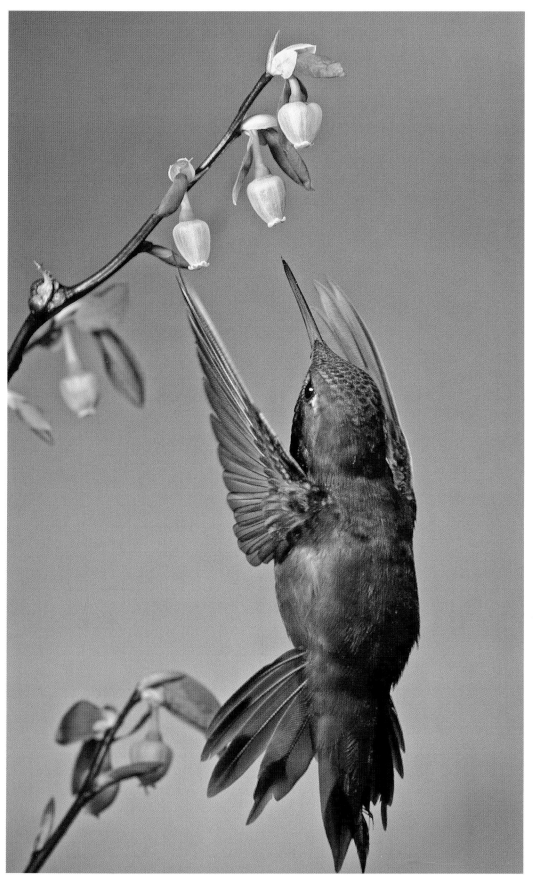

Rufous Hummingbird at early blueberry flowers. *I needed a photograph of a Rufous Hummingbird at early blueberry flowers because of an article a friend and I were writing about these flowers, which usually bloom in early April about the same time that hummingbirds arrive. Our observations indicated that hummingbirds fed heavily on the flowers, and we suspected the birds were important pollinators. To get this photo I put a vase with early blueberry blossoms near my hummingbird feeder. It worked well, as most birds stopped by to check out the blossoms. I used four electronic flashes, two trained on the flower and two on a background of colored composition paper. All were coordinated with a flash meter. I triggered the equipment from the comfort of my living room.*

Nikon F3, 105mm Micro-Nikkor lens, Kodachrome 64, Nikon infrared triggering device.

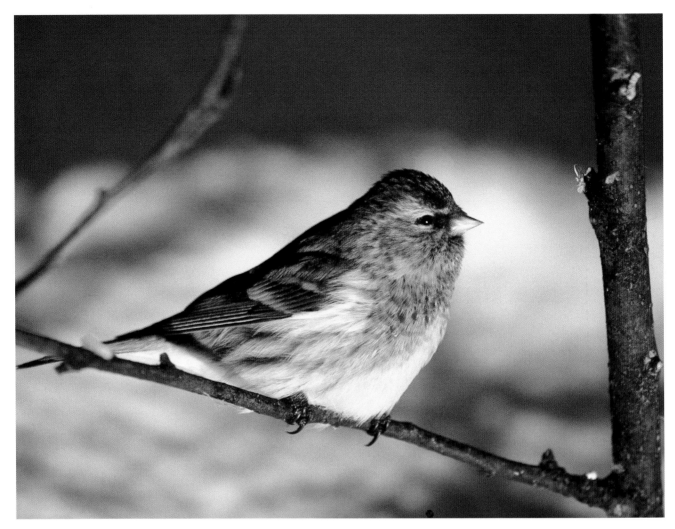

Minolta X-700, 100 mm macro lens, Kodachrome 64, Minolta infrared triggering device.

Common Redpoll. *This photo was taken at my feeder in Fairbanks. It was below zero outside, so by using the remote device I was able to trigger the camera from the comfort of the house. I noticed the birds would typically perch on this branch before going to the feeder, so I focused the camera on that spot.*

Keen's deer mouse. *To get this photo I captured a mouse and put it into a terrarium. I also put in two stones, and the mouse typically would jump from one stone to the other. By positioning the infrared beam between the two stones I was able to capture the mouse jumping. This was a very interesting experiment. I captured the mouse with a live trap set in the woods. When I introduced the mouse to the terrarium it immediately went over and drank out of a hamster water bottle, then ate some seeds and settled in as if it was a pet.*

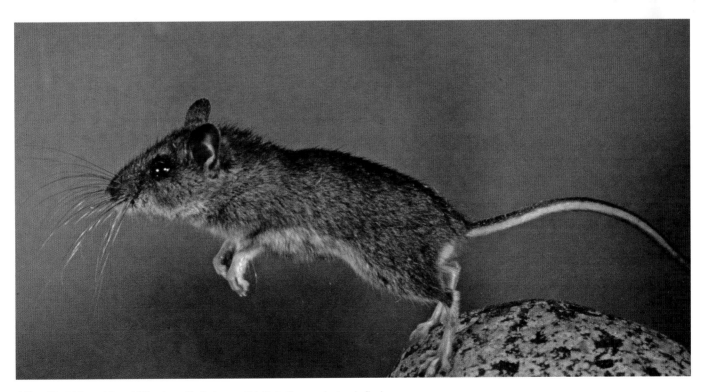

Nikon F3, 105mm Micro-Nikkor lens, Kodachrome 64, Dale Beam, electronic flashes.

The Bear Incident

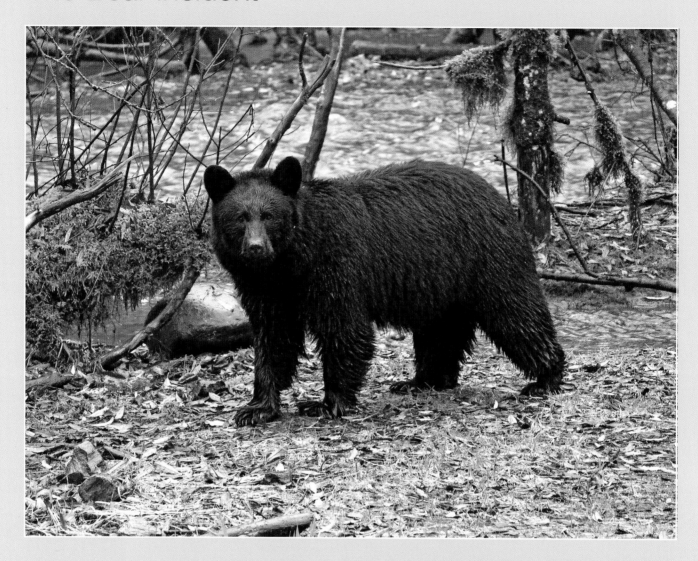

I usually do not use remote triggering devices for photographing larger mammals because large animals are fairly easy to photograph with telephoto lenses from a distance. Also, I worry that large animals might inadvertently or on purpose harm the equipment. In one case my fear was not unfounded.

I wanted to photograph black bears capturing salmon in a riffle, and I wanted a ground-level photograph to give a somewhat different and more realistic perspective. So, using a small table tripod, I focused my Panasonic FZ-30 with Pocket Wizard on a particular riffle area that the bears frequented.

After setting up my equipment I backed up a couple hundred feet and waited. About 15 minutes later a black bear came out of the woods and stood for several minutes staring at me. It then very deliberately walked over towards the camera and riffle area. In anticipation, I triggered the camera to take photos in a continuous mode.

Much to my surprise (and horror) the bear walked up to the camera, very gently knocked it over with its paw, and lay down and began rubbing its face on it. Then it got up, went out onto the riffle, and began fishing.

You can probably imagine what happened next. With the camera tipped over, I could not shut it off using the remote device. So I got one photo of the bear's paw and 256 photos of mud. I had another camera with me but I was too flustered to take any photos of the situation. Instead, I waited until the bear vacated the area, then went down to retrieve the camera. Much to my surprise and relief, the equipment was only slightly muddy but otherwise unharmed.

I suspect the bear had been watching when I set up the equipment and, perhaps out of curiosity, wondered what it was all about. Either that, or it simply did not want to have its photo taken.

Remote Triggering Devices: Photo Tips

The remote triggering device that I now use the most is the **PocketWizard Plus II.** This device can send or receive radio signals and can trigger a camera from a point up to 1600 feet away (according to the manual). I use mine mostly between 100 and 200 feet away from the subject. To operate requires two of them—one connected to the camera's motor drive port, and the other hand-held. With these you can either fire the camera's shutter one at a time or in a continuous mode.

These devices are quite small and easy to take with you. They're 1.4 inches deep by 2.1 inches wide by 4 inches tall, and they weigh less than 5 ounces with batteries.

Shutter release cables for the PocketWizards are available for most DSLR cameras. I could not find one for my Panasonic FZ30 camera, even though it had an external port; however, I was able to have a cable modified for the Panasonic at Harbortronics in Gig Harbor, Washington.

Many camera brands have their own external triggering devices. I have successfully used those made for Nikon and Minolta cameras, and had the devices modified to work with other brands. The ones I have used have been infrared triggering devices that work well at distances up to 200 feet.

One reasonably priced triggering device is the **JJC WR-100 Wireless Controller**. The manufacturers of this controller sell cables that are compatible with many different camera brands.

I have successfully used the **Dale Beam** I described earlier in this section. The device has a sensitivity dial that you can adjust so that even an insect's antenna will trigger the device (See Insect Flight Box). The Dale Beam is fairly small and easy to pack with you. I have successfully used it in the rain, covering it with a small plastic bag. The Dale Beam can be rented from Camren Photographic Resources.

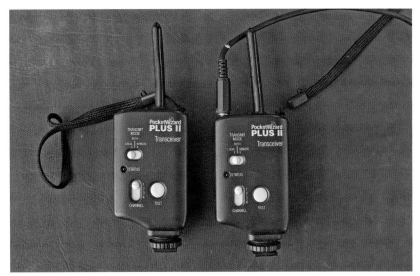

The PocketWizards

The Dale Beam

Sometimes when I set up remote triggering devices near a bird's nest they are used as a perch.

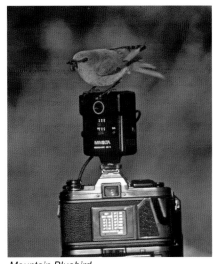

Mountain Bluebird

63

Using a Blind

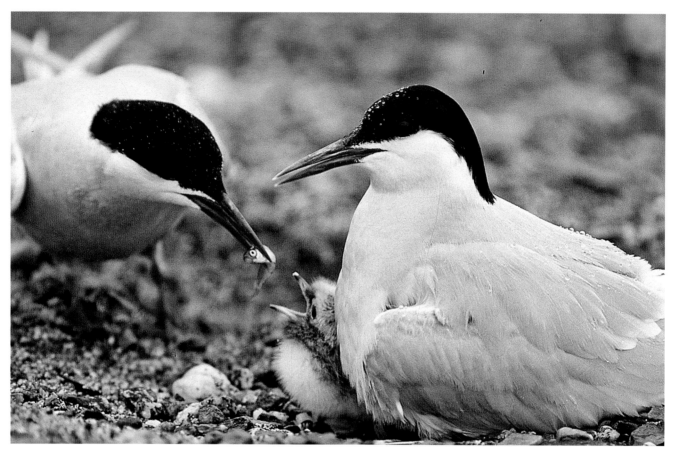

Nikon F3 with 300mm Nikkor ED telephoto lens, Kodachrome 64.

Arctic Tern feeding its chick. *When I emerged from the blind after taking this photo, one of the terns flew at me and pecked my forehead. With blood dripping down my face I quickly assembled my gear and left. No doubt I deserved the rude treatment.*

Many years ago I noticed an ad in a birding magazine for a blind that sounded intriguing. It consisted of a lawn chair, aluminum tubing, and camouflage fabric. Apparently a man designed the blind for his wife, who was studying bird behavior. It worked so well he decided to make some and sell them. The price was only $30, and he offered free shipping.

This simple blind worked great. It has held up well, and I still have it after about 35 years. What I really liked about it was that you could be very comfortable inside, and even have a cup of coffee while waiting for your subject to perform. It was very light, only a little bulky, and quite portable. Once inside the blind you could stand up a little and reposition it without having to emerge and scare your subject. It worked so well that I never tried any other portable blinds.

I used the blind mostly at bird nests, but it also worked quite well for photographing sea ducks. I would find a concentration of scoters, goldeneyes, or Harlequin Ducks feeding near shore. When the tide was coming in I would estimate where it would be about an hour after I had set up the blind. Setting up nearly always scared the ducks away, but usually they returned after about an hour. One time I misjudged where the tide would be, and when the ducks returned the water was rising within the blind. I stayed as long as I could stand the cold water in order to get some photographs, and I was lucky. Some of the ducks came quite close, and one male Harlequin Duck actually swam into the blind.

I discovered fairly early that an automobile makes an excellent blind, especially for birds and other animals that frequent roadside ponds or other areas near roads. In general, I found that most animals were used to automobiles, but usually flew or ran away if a person stepped out of the car. On several occasions I photographed feeding eagles from my car. Usually, however, people driving by would notice the eagles, stop their cars, step out with cameras in hand, and scare the birds away. I have often thought that when I reach an age where I have

trouble hiking I might take road trips throughout Alaska looking for places to take photographs from my automobile.

Once I tested the automobile as a blind on a farm road down South. I figured that with the advent of freeways, side roads would be nearly free of traffic. I parked the car just off the shoulder in a rather attractive spot and waited. Within an hour I had good photos of a buzzard, two mockingbirds interacting, a rattlesnake, a butterfly, and several other creatures I can't remember.

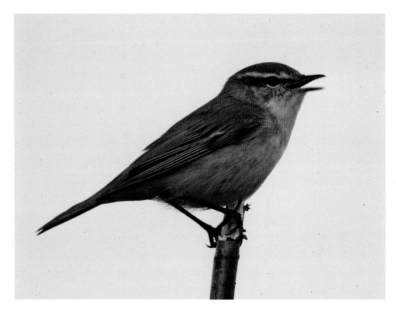

Nikon F3 with 300mm Nikkor ED telephoto lens and 1.4 extender. Kodachrome 64.

Arctic Warbler singing. *One summer when I needed a photograph of an Arctic Warbler for my Guide to Birds of Alaska, I found an area along the Denali Highway where several males were singing. At first I set up a blind and played a recording of a male Arctic Warbler singing about 10 feet from the blind. But this technique failed to attract any birds close enough to photograph. Finally I returned to the car and, mostly in desperation, I hung the recorder over the outside mirror and played the song again. Much to my surprise it attracted several males, and a couple even tried to get into the car. Apparently they did not see the automobile as a threat, but the strange blind set in the bushes scared them.*

Willow Ptarmigan feeding on willow catkins. *I photographed this male Willow Ptarmigan along the Denali Park Highway from the comfort of my automobile. While driving into Camp Denali I noticed the bird feeding in a willow by the road. I stopped the car and took several photographs from an open window. The bird seemed not at all concerned about my presence.*

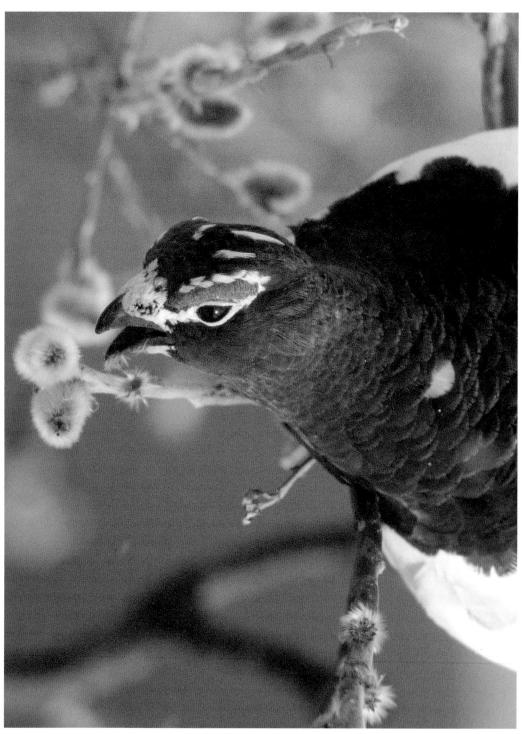

Nikon F3 with Nikkor ED 300mm telephoto lens, Kodachrome 64.

Surfbird on nest. *I discovered a Surfbird nest while hiking on a ridge above Camp Denali. At that time the area was outside the park boundaries. I didn't see the nest until the bird flushed right under my feet. I was very excited because, to my knowledge, no one had yet photographed a nesting Surfbird. I marked the site with a rock cairn. On subsequent visits the bird blended so well with its surroundings that I had to stare at the marked spot for several minutes before I could see it. I first set up my blind about 40 feet away from the nest. For the next three days I hiked up and moved the blind closer each day so as to get the bird used to the blind and not disturb it. At first I sat in the blind and watched the bird through binoculars. On one occasion it started snowing, and I watched the bird spread its wings out in a sort of semicircle, which gave more protection to the eggs. Also, when it was snowing an arctic ground squirrel came and sat inside the blind with me. Finally, I had the blind close enough to take good photos. It was a warm, sunny day, so after dismantling the blind I slowly approached the Surfbird. I stopped about three feet away, and the bird still didn't move. It was perfectly camouflaged. No wonder so few Surfbird nests have been found!*

Nikon F3 with Nikkor ED 300mm telephoto lens and 1.4 extender, Kodachrome 64.

Using a Blind: Photo Tips

In designing a blind it is important to include camouflage windows in all sides. This enables you to see your subject coming and get prepared to photograph. A camouflaged window on either side of the front slit for the camera will help you see your subject. You might also consider slits for your camera in the sides and back of the blind. Sometimes subjects other than what you plan to photograph show up and perform off to the side or back.

I recommend using a quick release plate on your tripod. This gives you the flexibility to move the camera about quickly inside the blind without having to move the tripod, which may scare your subject.

If you're photographing from a car, a window mount or bean bag helps to steady the camera. Unfortunately, this can be difficult because most modern automobiles have slanted windows. Part of the reason I purchased my present vehicle, a Honda Element, was because it had squarish windows that I could attach my Bogen window camera mount to. A firm attachment was necessary for digiscoping.

An automobile makes an excellent blind for digiscoping. Since it is darker inside the vehicle you can more easily focus with the LCD screen. Also, it can be a comfortable place to wait.

Calls and Decoys

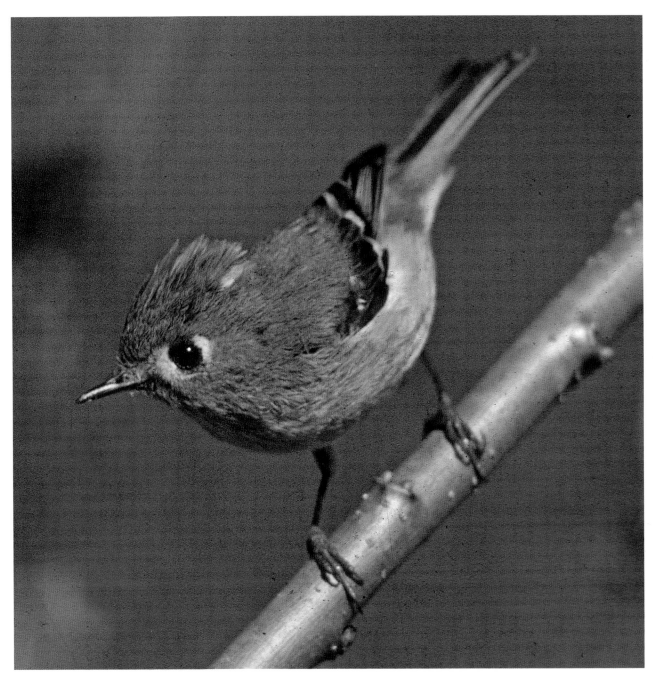

Nikon D3 with Nikkor ED 300 mm lens, 1.4 telextender, Kodachrome 64.

Ruby-crowned Kinglet. When I played a recording of this male singing, it immediately responded by coming close.

Woodpecker territoriality.

For woodpeckers, drumming serves the same purpose song does for many other birds. It proclaims a bird's territorial boundaries to others of its species.

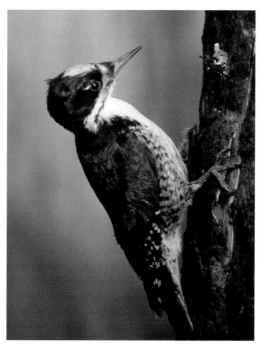

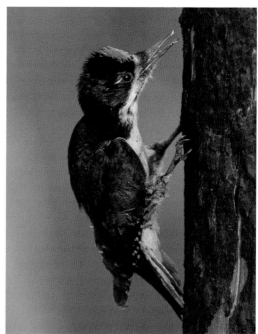

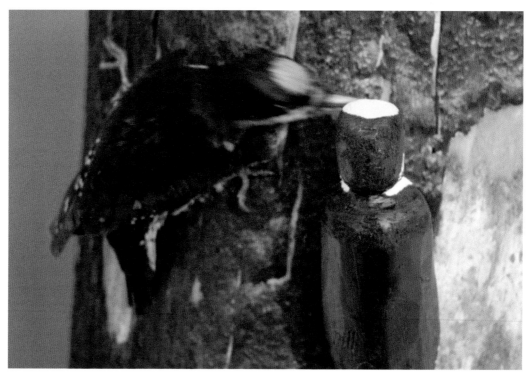

A friend and I once instigated a demonstration of woodpecker territoriality. We carved a model of a Black-backed Woodpecker with legs made of nails and attached it to the trunk of a tree at eye level. Then we played a recording of a Black-backed Woodpecker drumming underneath it. Within a few minutes a Black-backed Woodpecker flew to the model and attacked it, pecking fiercely at its head. As I took photos, the "real" woodpecker eventually knocked the "intruder" to the ground, then flew off and fed quietly nearby.

The top left photo was the one I wanted for the field guide. The one next to it shows the same bird getting quite upset. The bottom photo could be titled "the last straw."

I used to make recordings of birds singing. I had a fairly large parabola to concentrate the sound, and a fairly heavy portable recorder. My main goal was to make a library of bird sounds and to learn them. However, the method did have some advantages for photography.

Male song birds sing to establish territory and to attract a mate. Hence, if you play a recording of them singing they often come closer to investigate and in some instances attempt to drive an apparent intruder away. By putting the recorder under a particular tree, for example, you could sometimes attract the bird to that tree and take its photograph.

The ethics of doing this can be questioned. If you do it too much you might drive the bird from its territory or simply be too disruptive. Playing bird songs is usually prohibited in National Parks, such as Denali. However, when you are attempting to put together a photographic guide to the birds of Alaska, playing bird songs, or finding birds' nests, may be the only way to take photographs of some species. I was always careful. I would quit after about half an hour so as not to be too disruptive. Also, I would choose fairly remote areas where birders or other photographers were not likely to be using recordings as well.

Playing bird sounds can result in some unusual situations. I once had a Western Screech Owl attack the tape recorder that was hanging over my shoulder. Once when I played the winnowing sound of a Wilson's Snipe, a snipe plummeted out of the sky and landed on the recorder, cocked its head, and stared at it.

In an Aquarium

Decorated warbonnet. *This photo was taken at the aquarium at the Auke Bay Biological Laboratory in Juneau. These members of the prickleback family look as if they have miniature forests growing on their heads.*

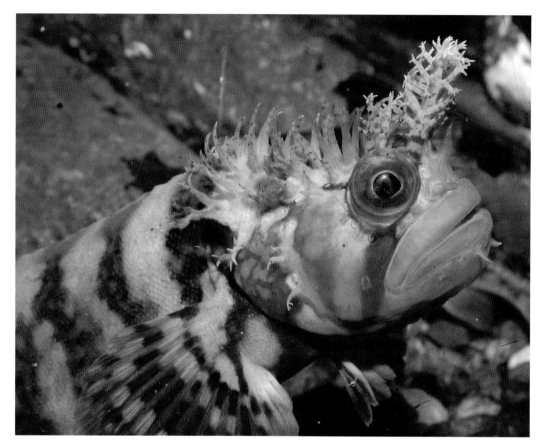

Nikon Coolpix E995, Nikon Speedlight SB-30 off camera, black velvet.

You don't need scuba gear and expensive camera equipment to photograph some of Alaska's smaller aquatic life. I have brought small aquariums into the field and captured an aquatic insect, taken its photograph, then returned it to the wild. I have also visited aquariums that are open to the public and taken photos of Alaska's fish in a fairly natural setting.

For best results use a piece of black velvet with a hole cut in it for the camera lens. This will cut out the reflections of your camera in the glass. I usually mount the black velvet on a piece of cardboard or Styrofoam. Also, it helps if you use a hand-held electronic flash attached to your camera by a cord.

Point-and-shoot cameras that allow for an off-camera flash have worked well for me. Their light weight and greater depth of field make them easy to hand-hold. You should hold the flash at an angle so that it does not reflect back into the camera.

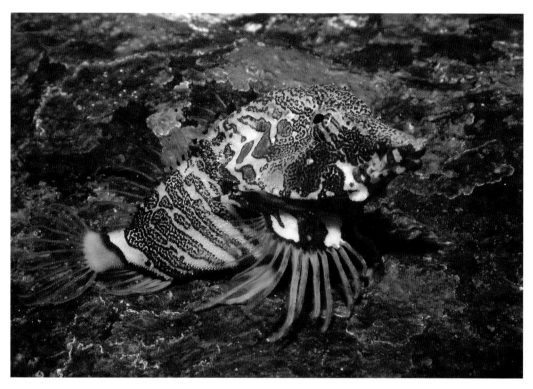

Grunt sculpin. *This photo was taken at the aquarium at the Auke Bay Biological Laboratory in Juneau. Grunt sculpins get their name from the grunting and hissing sounds they make when they're removed from the water.*

Nikon Coolpix E995, Nikon Speedlight SB-30 off camera, black velvet.

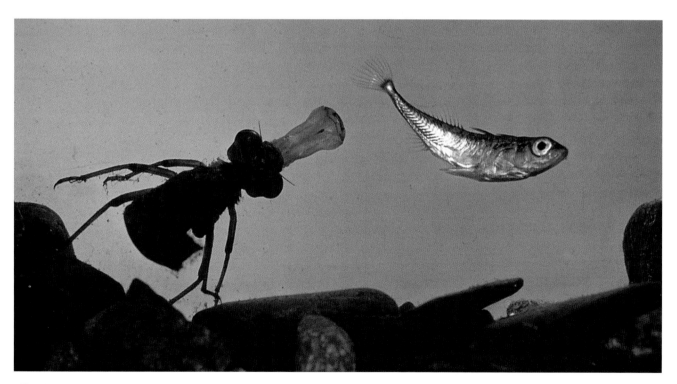

Nikon F3, Micro-Nikkor 105mm lens, electronic flashes, Kodachrome 64.

Dragonfly larva attacking stickleback. *To get this photo I sat behind a piece of black velvet, with a hole cut for the camera lens, so as not to disturb the dragonfly larva. Once the larva started to attack the fish I would fire the electronic flashes on a continuous mode.*

Insect Flight Box

African migratory locust. *This photo was a very pleasant surprise as I was unaware that the insect had flown out of the box.*

Nikon F3 with MD-4 motor drive, Nikon Micro-Nikkor 105-mm f/4 lens, f22, electronic flashes set at 1/20,000 of a second or higher, Vincent external shutter, Kodachrome 25.

After reading Steven Dalton's book *Caught in Motion* and looking at his stunning photographs of insects in flight I had to try his technique. I am not very adept at electronics so it took me about a year to put all the equipment together. I was proud of what I had done because the equipment and flight box cost less than $1,000 and could be used under field conditions.

I finished the project in early winter when there were no insects to work with.

I contacted the Worldwide Butterfly Farm in England and asked if I could visit and try out my flight box. Much to my surprise they agreed. They seemed curious and said this was the first request of this sort they had ever received. So I bundled all the stuff into a large Pelican case and flew to England.

The folks at the farm were very accommodating. They let me use a vacant room and allowed me to take insects from their live displays and put them in the flight box. The room was small, so it was easy to capture the insects afterwards and return them to their respective cages. The equipment seemed to work ok and most butterflies would fly out of the box and trigger the photo equipment. When I was done and dismantling the equipment I noticed a locust was sitting on the windowsill. I remembered putting it in the box but never noticed it flying out.

After I returned to Juneau I had to wait about two weeks before the film could be developed and I could see if the equipment really worked. I got lots of butterflies in various flight poses but was really pleased and surprised by one photo—a sharp, completely in-focus image of an African migratory locust!

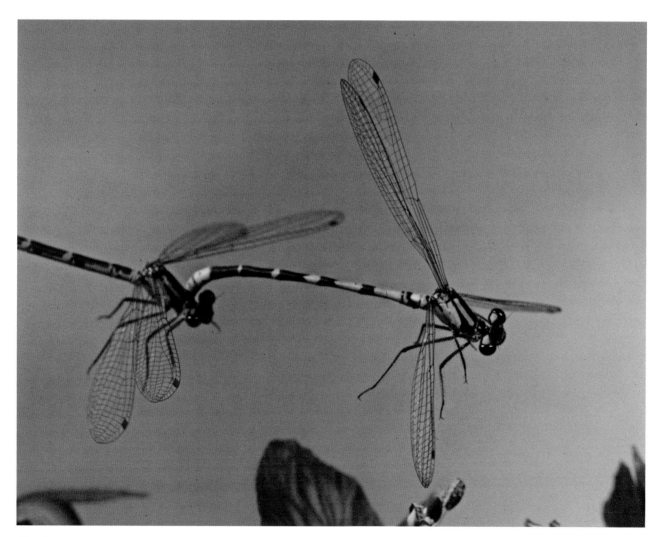

Nikon F3 with MD-4 motor drive, Nikon Micro-Nikkor 105-mm f/4 lens, f16, electronic flashes set at 1/20,000 of a second or higher, Vincent external shutter, Kodachrome 25.

Damselflies in tandem. I had put several damselflies, both male and female, in the flight box. One male decided to grab a female for mating and flew out of the box with her in tow.

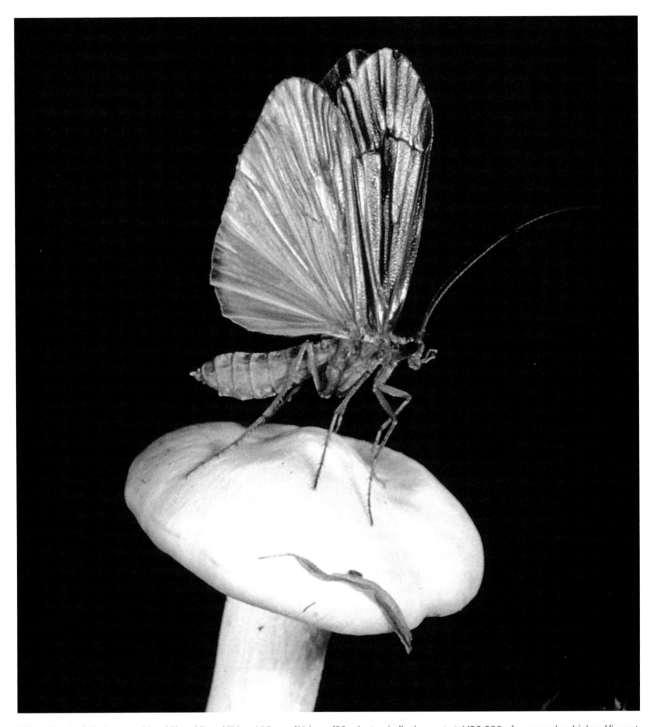

Nikon F3 with MD-4 motor drive, Nikon Micro-Nikkor 105-mm f/4 lens, f22, electronic flashes set at 1/20,000 of a second or higher, Vincent external shutter, Kodachrome 25.

Caddisfly taking off from a small mushroom. *This insect crawled out of the flight box and up to the top of this mushroom I had placed at the exit hole. When it raised its wings to take flight it triggered the camera setup.*

Nikon F3 with MD-4 motor drive, Nikon Micro-Nikkor 105-mm f/4 lens, f22, electronic flashes set at 1/20,000 of a second or higher, Vincent external shutter, Kodachrome 25.

Darner dragonfly cruising past mare's tail.

Their large size made dragonflies very easy insects to work with. Also, they were very predictable and generally flew out of the box in the middle of the exit hole.

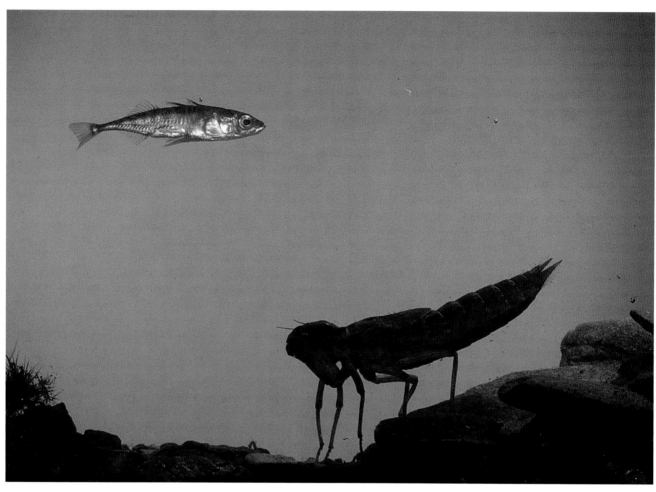

Nikon F3, Micro-Nikkor 105mm lens, electronic flashes, Kodachrome 64.

Dragonfly larva contemplating stickleback. *To obtain photos of dragonfly larva attacking fish I put a larva and a stickleback in a small aquarium. I placed the aquarium in the front part of the insect flight box. In this way I could use the box like a miniature studio. I used black velvet draped over myself with a hole just big enough for the camera lens. This avoided any reflection from the camera or myself on the glass of the aquarium. Once the larva appeared to start its attack I would take photos in a continuous mode. The flashes would be set at such a short duration, i.e. 1/20,000 of a second, that they recycled instantly. Once the larva started its attack it would not stop. However, if I started the flashes too early it would stop and retreat.*

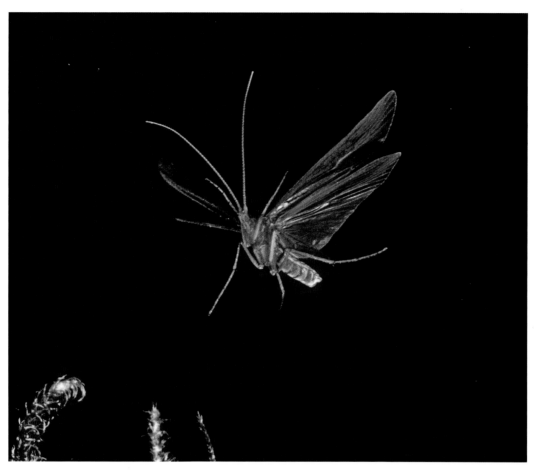

Caddisfly in flight.
Caddisflies typically fly at night, so using a black background helped simulate darkness. Also, they will fly towards light and can often be collected around your outside porch lights at night.

Nikon F3 with MD-4 motor drive, Nikon Micro-Nikkor 105-mm, f/4 lens, f22, electronic flashes set at 1/20,000 of a second or higher, Vincent external shutter, Kodachrome 25.

Insect Flight Box: Photo Tips

For details on the insect flight box and its operation see Armstrong, Robert H. 1990. "Photographing Insects in Flight". *American Entomology*. 213-217. Also see Cooke, J. & T. Tilford. 1987. "High-speed photography". *Photomethods*. 30(11): 53-57.

For best results use electronic flashes that can be operated manually and have a power ratio control to set the duration of the flash. Flashes set at 1/10,000 of a second or higher will usually freeze insects in flight. I used Sunpak 611 and 333 models.

When using an electronic flash at relatively low shutter speeds you need to overcome natural light to avoid ghosting (getting two images, one with natural light, the other with the flash). The best solution is to set your f-stop two stops or more higher than what you would for natural light.

Most 35mm film cameras and the DSLR's that I have checked have a delay in shutter release after receiving an external signal. Although this delay is not great (*i.e.,* 30 to 120 milliseconds) it is too long for the precise focusing needed to capture a flying insect at the point of the infrared beam. To overcome this I used an external shutter attached to the end of the camera lens. These shutters have a reaction time of about 6 milliseconds, which is sufficient for photographing flying insects. The camera's shutter was then held open in bulb and the external shutter was used instead. I used a Vincent model 225L, with case and mechanical

sync contact. To operate the shutter, I used the Vincent model PP-1000 portable shutter drive-timer.

Some cameras, such as the Rollei SLX and 6000 series cameras may have a short enough reaction time to an external signal that an external shutter is not needed. I suspect that some digital cameras may also work without an external shutter. I tried my Nikon D-300 but could not make it work sufficiently by itself or with an external shutter. Being able to hold the shutter open either manually or on a continued basis electronically would help.

To determine exposure with electronic flashes it helps to use a flash meter. This way you can coordinate several flashes to equal each other. I usually put one flash attached to the camera and the rest on slave units. When using electronic flashes set on manual and with a macro lens you may need to open up the lens by about one f-stop to compensate for a loss in light when doing close-up work.

I built a box of quarter-inch plywood with an opening in front so that when an insect flies out it passes through the infrared beam and triggers the external shutter and electronic flashes. The box is 18 in. long, 16 in. wide, and 10.5 in. high. It is designed to be dismantled and will fit into a standard Pelican camera case.

The flight box includes corkboard at the back for pinning on colored backgrounds. I used colored heavyweight construction paper that comes in 12- by 9-inch sheets. I spray-painted the paper to simulate out-of-focus colors that might be encountered in nature, as in woods or sky. At the open front of the box, I installed slots so that cardboards with different sized exit holes can be inserted, depending on the size of insect to be photographed. An exit hole of 4 by 5 inches works well with most of the larger insects, such as butterflies and dragonflies. The flight box has uses other than photographing insects in flight. The consistent illumination of a background facilitates taking portraits of insects and photographing aquatic insects placed in a small narrow aquarium.

The infrared tripping device I used was called a Dale Beam. This device sends out a pulsed beam of infrared light that is bounced off a small reflector and back to a built-in sensor. A sensitivity dial can be adjusted so that even an insect's antennae entering the beam will trigger the external shutter. The Dale Beam also has audible and visual devices that help to locate the infrared light beam precisely, which is essential for critical focusing of the camera's lens.

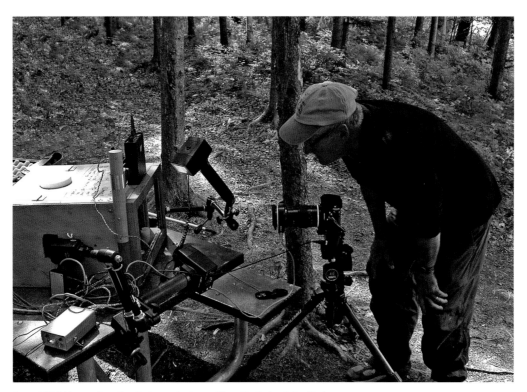

Insect flight box set up to photograph dragonflies. Photo by John Hudson.

Strategies

Stalking

Waiting

Using the Weather

Best Time of Day

Visit a Park

Put Up a Feeder

Stalking

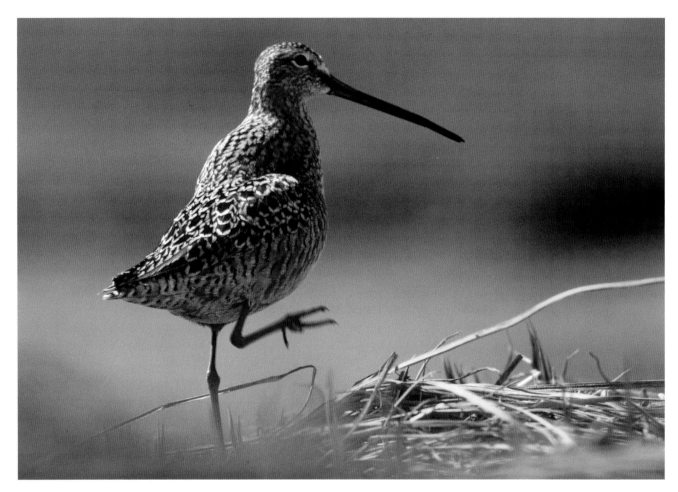

Leicalflex 35mm camera, 400mm Leicaflex lens with bayonet mount. Kodachrome 64.

Long-billed Dowitcher.
I like the perspective that crawling gives. You are on the same level as your subject.

In my opinion, stalking is one of the worst ways to get close enough to photograph wildlife. Usually it results in the creature fleeing or a photograph of the subject staring at you. Unfortunately, it is one of the methods that many photographers commonly use. When I am around other photographers and see the group walking or running after a subject, I turn and walk away. There is, however, one exception: a technique I call the "Commando Stalk."

Commando Stalk

You can get close to many birds by crawling, commando style, lying flat on the ground and moving forward using your elbows. I used to do that a lot to photograph birds on the wetlands. I started out wearing rain gear to go through the mud, but the gear just got all ripped up. So I decided being wet, muddy, and miserable for awhile was just part of the job.

For some reason many birds—particularly shorebirds—don't consider you to be a danger if you're lying flat on the ground. If you get up on all fours they immediately take flight, but if you stay low you can get amazingly close to them.

I've crawled in among flocks of shorebirds and had them falling asleep all around me. Then I've crawled back out again without ever

disturbing them. That's a really neat experience. You can use a small table tripod to keep the camera out of the mud, and inch that ahead of you as you move along. When shorebirds are on their nesting grounds, though, they are often surprisingly aware of you when you're crawling. Sometimes if you can crawl along and suddenly drop out of sight, say by dropping down into a swale, then they'll walk right up to you and look to make sure you're still there.

Bob photographing a Sanderling. *This is an example of the crawling technique. It works really well with shorebirds.*

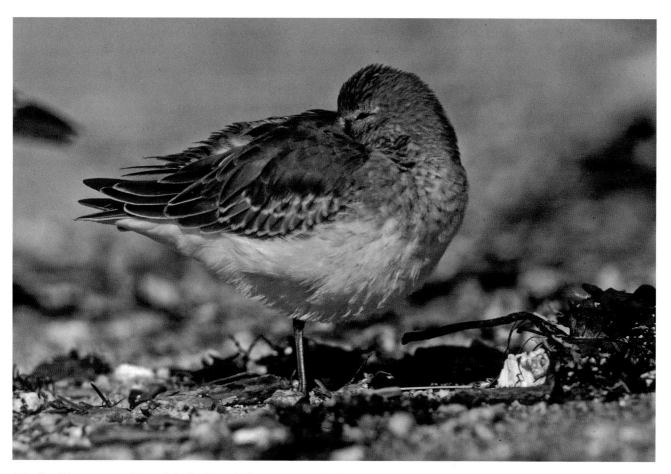

Leicalflex 35mm camera, 400mm Leicaflex lens with bayonet mount. Kodachrome 64.

Dunlin taking a nap. *Often I was able to crawl in amongst shorebirds and had them fall asleep around me.*

Nikon D-300, AFS Nikkor 70-300 mm lens, focal length 300mm, f/7.1 at 1/500 second, ISO equivalent 800, no exposure compensation.

Sitka black-tailed deer. *This is an example of what can happen when you stalk wildlife. In this case, when I finally got within good photo range the deer noticed me, looked at me, and then fled.*

Stalking: Photography Tips

If you must stalk upright, moving towards your subject in full view seems to work best. If you attempt to hide while stalking, your subject will usually become alarmed if it catches a glimpse of you. I usually move very slowly, and carefully watch the subject's behavior. If it seems to be concerned I generally stop and wait until it resumes normal behavior. If it is obviously alarmed and starts to move away, I stop approaching it and abandon the effort.

When you're stalking I suggest you avoid using a tripod. Clanking legs or the noise and movement of a tripod getting hung up in brush usually adds to the probability that your subject will flee. Monopods or hand-held techniques seem to be best.

Waiting

Painting by Ed Mills.

Photographing Dall Sheep. *Aside from all the tricks and complicated equipment I've used over the years to photograph wildlife, I've had some of the best experiences just sitting still with my camera. Once when I was hiking a ridge in Denali National Park I sat down to enjoy the scenery and have lunch. There were some Dall sheep in the distance and gradually I realized they were moving toward me. I just sat there, and pretty soon I was completely surrounded by a group of sheep, some of them so close I could hear them eating. They totally ignored me.*

Meanwhile, way down the mountain, I could see two photographers crawling up the hillside, coming up to photograph these Dall sheep. They spent close to two hours stalking, creeping along, dodging from one rock to the next. Finally they got within photographic range. I can still see the expressions on their faces when they emerged and saw me sitting there in the middle of that flock of sheep.

Sora. I had an interesting experience with a photographer from the Netherlands by the name of Edwin Winkel. Edwin is one of the best bird photographers I have met. We were together in Juneau and we wanted to photograph a Sora, a very secretive bird and a rare one for Alaska. Edwin had experiences with other species from the Sora family and said if you focus your camera on this one spot for two hours you will get a photo. The spot was a small opening among the abundant sedges growing in the marsh. He was right. After one and one-half hours the bird appeared for a few seconds and I got my photo.

It's not a very dramatic photo, but it's the only one I have ever taken of this species. This is an extreme example of the Sit and Wait approach—or should I say the Sit and Stare approach.

I believe the Sit and Wait approach is by far the best method to photograph wildlife. One bonus to this method is that you can usually capture images of subjects doing what they do naturally and not posed looking at the photographer.

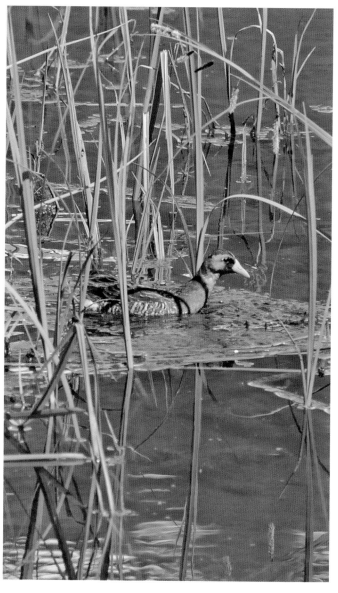

Nikon D-300, AFS Nikkor 70-300 mm lens, focal length 300mm, f/8 at 1/1250 second, ISO equivalent 1000, no exposure compensation, 6/1/09, 11:20 a.m.

Sit and Wait: Photo Tips

A tripod can be useful for this approach particularly if focusing on one spot would be advantageous. It helps you to be ready and avoid becoming too tired from holding your camera ready. Sometimes using a remote triggering device helps to capture the special moment. Having your tripod equipped with a quick release plate is important in case the subject moves away from the focused area. In general I do not like to use a tripod because of the difficulty in quietly moving it about without scaring your subject.

Pre-focusing the camera and making all of the necessary camera settings ahead of time can make the difference in capturing that special moment. I usually leave the camera on and turn off any of the sleep modes. Always carry enough batteries.

Marmots touching noses. *I sat near these two young marmots for about 2 hours. After playing together for awhile they separated for about 20 minutes. When they saw each other again one ran up to the other and touched noses with it. It was a difficult photo shoot because there were numerous people on the trail and every time someone walked by the marmots would dive into their den. Patience, sitting still, and waiting worked.*

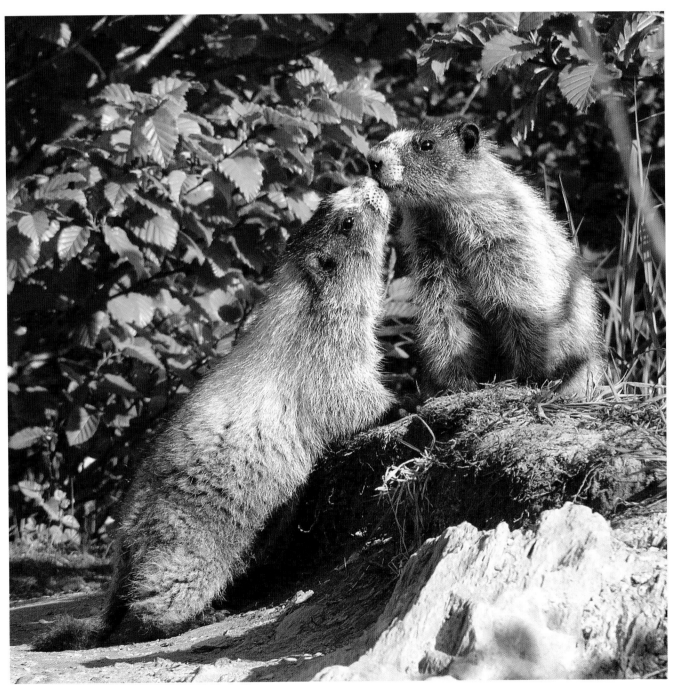

Panasonic DMC-FZ10, focal length 52mm, f/5.6 at 1/320 second, ISO equivalent 100, minus 0.7 exposure compensation, 6/7/05.

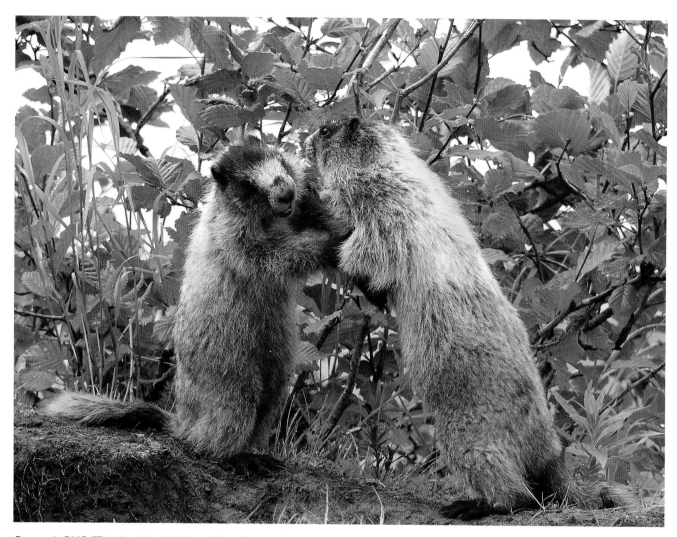

Panasonic DMC-FZ10, focal length 34mm, f/4 at 1/400 second, ISO equivalent 100, minus 0.3 exposure compensation, 6/21/05.

Marmots boxing. I loved watching these young marmots play. They would wrestle with one another, tumble on the ground, and stand on their hind legs and push each other with their front feet as if they were boxing.

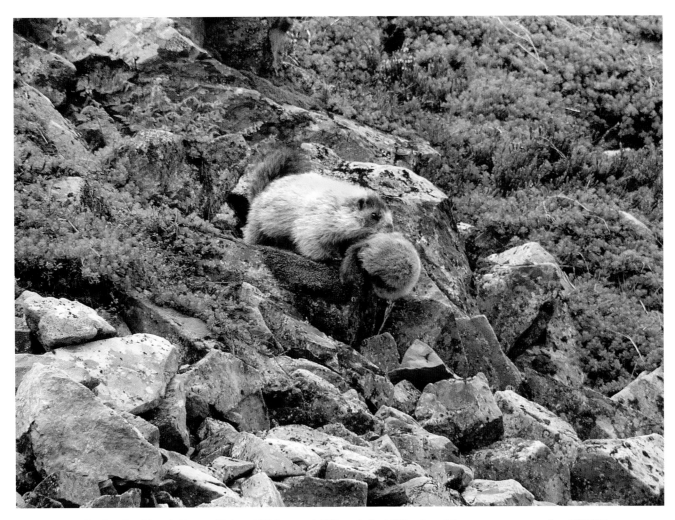

Panasonic DMC-FZ10, focal length 72mm, f/2.8; at 1/320 second, ISO equivalent 100; minus 0.7 exposure compensation, 6/30/05.

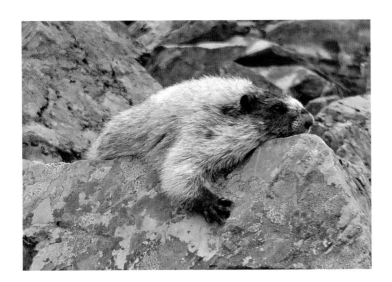

Marmot mother moving her youngster. *On another day when I was watching a family of marmots it was warm and sunny and I had a comfortable spot to sit with a good friend. We were eating smoked salmon and crackers and watching two large marmots. One was quite busy carrying vegetation into the middle of a rocky area. The other lay sprawled out sunning itself on a flat rock. From what I knew about marmot behavior I assumed the busy one was a female and the lazy one the male. The female began running up to a nearby meadow and bringing her youngsters down, apparently to a new den in the rock pile. She brought four young ones down, all while the male slept on the flat rock. After the fourth one was delivered the male ran up to the old den in the meadow and looked and then ran down to the new den amongst the rocks and looked. Then, apparently satisfied that the job was done, he went back to his resting place and fell asleep.*

The Lesser of Two Evils

When I was taking photographs for the book *Life around Mendenhall Glacier* I needed images of black bears. One of the best places to get them was from the salmon viewing platforms along Steep Creek at Mendenhall Glacier in Juneau. This was also where lots of tourists gathered to view the salmon and bears. So I started out by arriving to take photographs a couple of hours before the bus loads of tourists arrived. Usually I would see only a few bears, or none at all, until the platforms became crowded with people. This happened many times and I wondered why.

Finally, I realized that most of the bears that fished near the platforms were young bears or females with young. These bears are typically afraid of the more aggressive adult male bears, which are usually wary of humans. It appeared that the bears were using the humans to keep the adult male bears away. In other words, we were the "lesser of two evils."

Young black bear with sockeye salmon.

This young bear captured a sockeye salmon that had become stranded on a gravel bar while attempting to negotiate a riffle in the creek. The bear, with its lack of experience, was having a tough time catching salmon and took advantage of the stranded fish. This happened in front of numerous people standing on the salmon viewing platform.

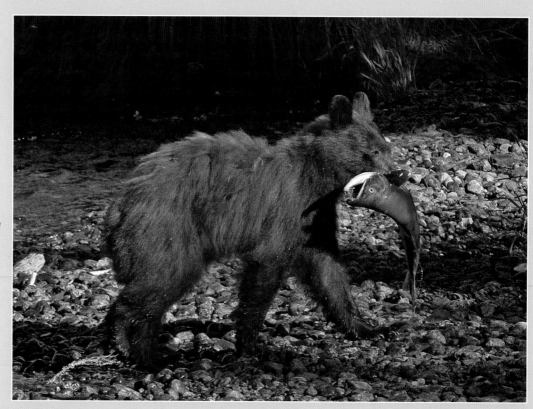

Panasonic DMC-FZ30, focal length 89mm, f/3.7 at 1/500 second, ISO equivalent 100, no exposure compensation, 8/15/07.

Panasonic DMC-FZ30, focal length 80mm, f/3.7 at 1/800 second, ISO equivalent 100, minus 0.7 exposure compensation, 8/12/07.

Mother black bear with cubs. This black bear sow with cubs walked right up to and under the salmon viewing platform at Mendenhall Glacier. The platform was jammed with excited tourists.

Panasonic DMC-FZ30, focal length 87mm, f/3.7 at 1/400 second, no exposure compensation, 12/12/06.

Great Blue Heron standing next to car. *I had another experience that helped gel some similar thoughts together. Driving along a road early one morning I noticed a couple of Bald Eagles feeding on a salmon carcass along an ice-covered pond. I slowly pulled over and rolled the window down to photograph them. But I was too close and caused the eagles to fly away. Almost immediately a Great Blue Heron emerged from the adjacent forest and began feeding on the salmon carcass. After awhile, and much to my surprise, it walked up to my car and stood a couple of feet away from my open window and looked at me. That did it. I finally understood some of the many unusual experiences I have had with wildlife over the years.*

Marmot taking a snooze. *When I am watching marmots in the alpine they will sometimes fall asleep within a few feet of me. I believe these creatures are using me to help keep away their predators. I was sitting about 10 feet from this marmot when, apparently very comfortable with my presence, it decided to take a nap. It was a warm sunny day and lots of Bald Eagles were cruising by. Perhaps the marmot felt my presence would be sufficient to keep the eagles away.*

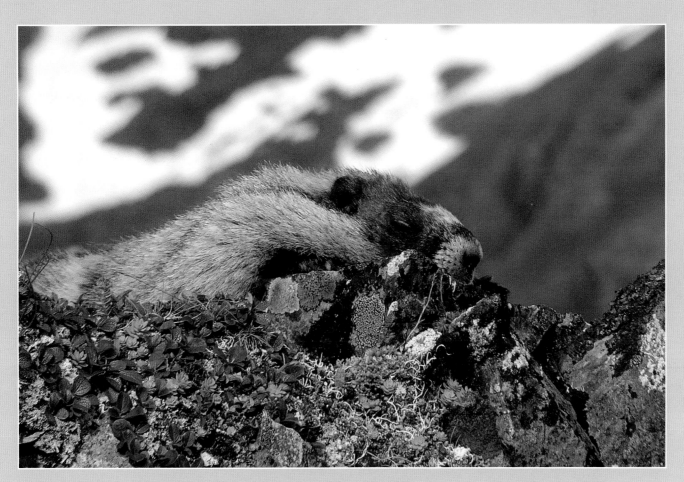

Panasonic DMC-FZ10, focal length 72 mm, f/5.7 at 1/1000 second, ISO equivalent 100, minus 0.7 exposure compensation, 7/22/04.

Using the Weather

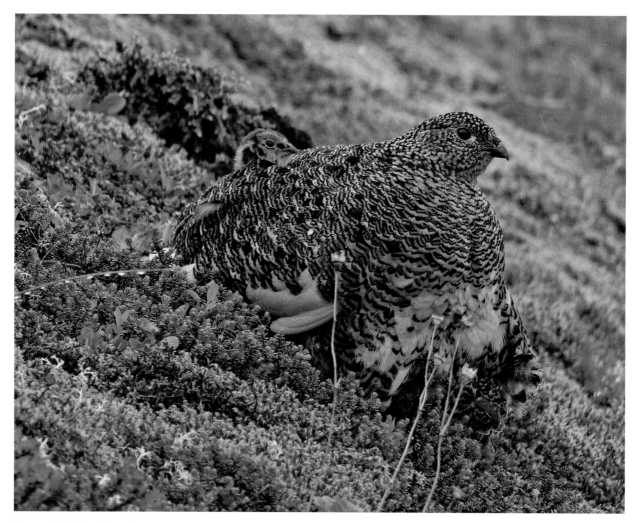

Panasonic DMC – FZ30, focal length 89mm, f/4 at 1/400 second, ISO equivalent 100, minus 0.7 exposure compensation, 7/8/06.

Willow Ptarmigan and chick. *I have gotten some of my best photographs in the rain. For one thing very few other people are out and about. In the alpine, eagles and other raptors are not usually hunting because of the poor visibility, so birds such as ptarmigan and grouse can be more approachable and easier to photograph. Also, animals often exhibit different behavior than they do on a warm sunny day.*

I have watched both ptarmigan and grouse mothers and chicks on a cool rainy day in the alpine. The chicks usually run about and forage for awhile, but then they seem to get somewhat wet and cool. At some point the mother fluffs her feathers and raises her wings a bit, and the chicks run and take cover beneath her. The photos above and on the next page illustrate this behavior. I was amazed by how accepting the females were of my presence. They allowed me to sit and watch from only a few feet away. Eventually one of the chicks usually peers out from under a wing to see what is going on. When that happens it creates a wonderful photo opportunity.

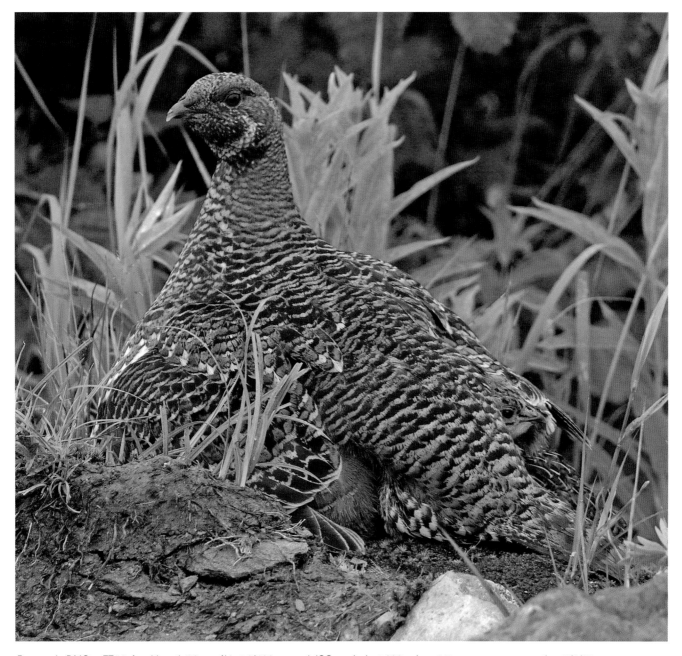

Panasonic DMC – FZ30, focal length 89mm, f/4 at 1/400 second, ISO equivalent 100, minus 0.7 exposure compensation, 7/8/06.

Sooty Grouse and chick. *This photograph was taken on a cool, drizzly day in the alpine.*

Panasonic DMC – FZ30, focal length 58mm, f/3.6 at 1/160 second, ISO equivalent 400, no exposure compensation, 11/6/06.

Porcupine on a snowy day. Going out during a snow storm can also yield some interesting images. If it's snowing particularly hard, snow can accumulate on an animal's back. If you're lucky you may be able to get a photograph before it shakes it off. A relatively slow-moving porcupine can be a good subject.

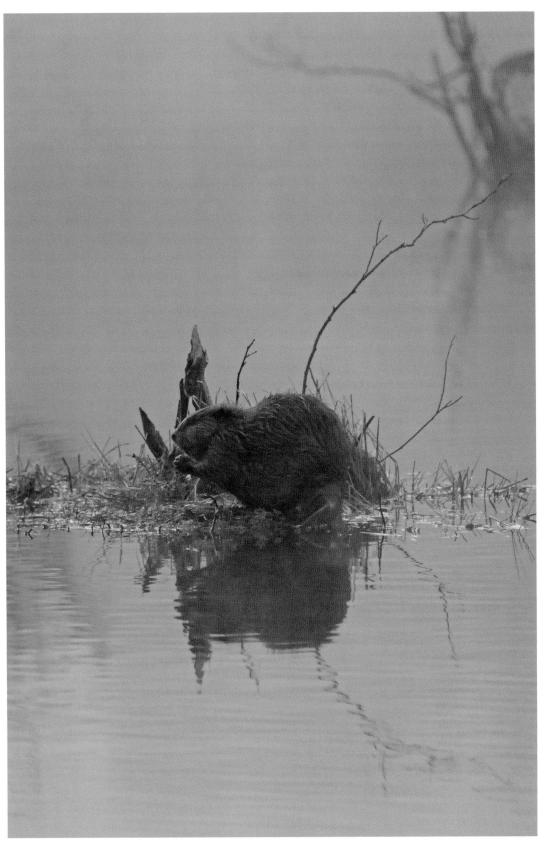

Beaver in the fog. *Almost all the photographs I took for a book on beavers were taken on rainy or drizzly days. One morning a blanket of fog added an interesting element to photography.*

Nikon D 300, AFS Nikkor 70-300 mm lens, focal length 300mm, f/5.6 at 1/1250 second, ISO equivalent 3200, manual exposure, 5/19/08, 6:10 a.m.

Marmot, baby, and cross in the fog. *One foggy day above the Mount Roberts Tram in Juneau a mother marmot and her youngster interacted with each other with Father Brown's Cross in the background. I thought the cross peering through the fog gave a surreal feeling to the photo. The prosumer camera with its great depth of field made this photo possible. I once exhibited this photo in a show and titled it "Hey, Mom."*

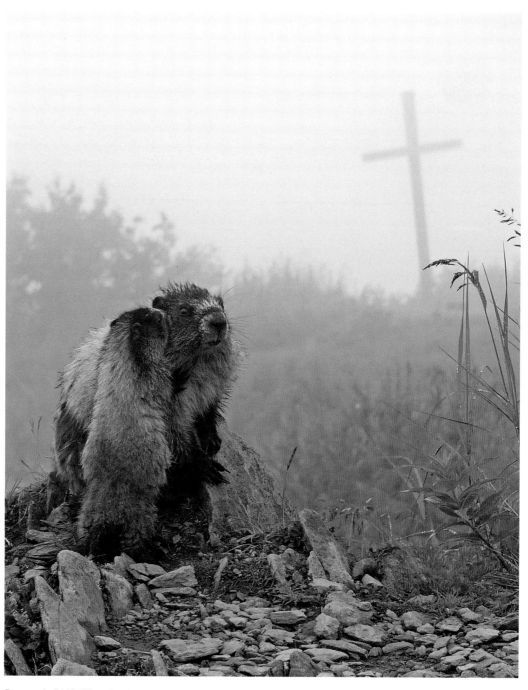

Panasonic DMC-FZ10, focal length 34mm, f/4.6 at 1/500 second, ISO equivalent 100, minus 0.7 exposure compensation, 7/11/05.

Protecting your Camera

When it's raining or snowing I protect my camera and lens with a camera rain cover from FotoSharp. It's also a good idea to carry a microfiber camera lens cleaning cloth with you to wipe any water off the end of the lens and viewfinder. At times I've also used a oversized umbrella, but I've noticed that sometimes the umbrella frightens certain creatures.

Plastic bags work great for protecting the gear in remote setups. Cut a hole for the lens and secure the bag with the lens hood. Remote triggering devices have no trouble working when enclosed in plastic.

Time of Day

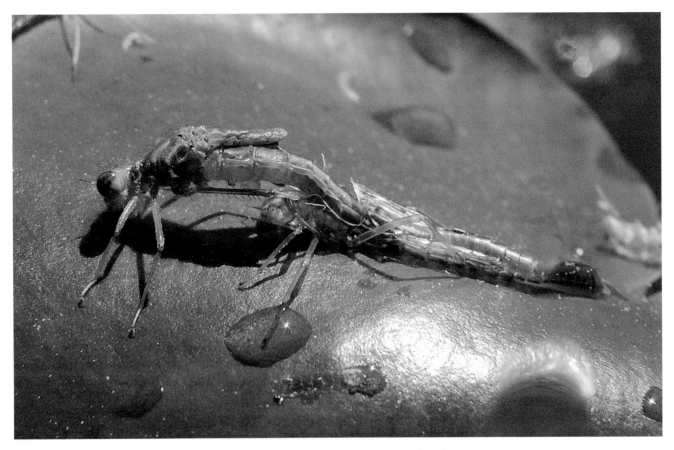

Panasonic DMC-FZ10, focal length 7mm, f/5.6 at 1/1300 second, ISO equivalent 100, minus 1 exposure compensation, 5/20/04.

Damselfly emerging from its exoskeleton.

Sometimes getting out at first light is necessary. To find damselflies emerging from their exoskeletons I had to visit this bog early in the morning about 5 a.m. When you see damselflies crawl out of the water, it's best to wait until they start coming out of the exoskeleton. Once that process starts, the insects cannot stop, so you can approach them quite closely. If you approach before the process begins, they usually retreat back into the water.

For scenery and good-looking portraits it is well known among photographers that morning and evening give the most pleasing light. Since I am most interested in capturing behavior and incidents, anytime is fair game, although being first out of the starting gate in the morning does have advantages.

Early morning ventures can be especially important in an urban setting. As more and more people wake up and venture about, wildlife usually becomes more wary. Dogs, in particular, love to chase other creatures. When I was photographing beavers my photographic sessions were usually terminated around 7 a.m. when the first dog walker arrived. At the sight of a dog, beavers would slap their tail, which unfortunately only served to stimulate the dog's chase instinct. The same was true for marmots, which usually whistle at the sight of a dog, again stimulating the chase response.

Even the sight of a dog can terminate a photo session. Once while I was photographing a family of marmots a person with a dog on a leash walked by. The marmots whistled, dove into their dens, and did not come out during the following two hours that I waited. Earlier in the day, when several people walked by talking loudly, and one even running, the marmots were not disturbed.

Other creatures, too, are often easier to photograph early in the morning. For example, in spring birds are often actively singing during the first couple of hours after sunrise.

Damselflies mating. *We camped on a lake and I tried to photograph mating damselflies without much success. I needed a very close side view to show the process clearly. I found this pair early on one cool morning, and they allowed me to approach to photograph them.*

Fujifilm FinePix 4700 point-and-shoot camera.

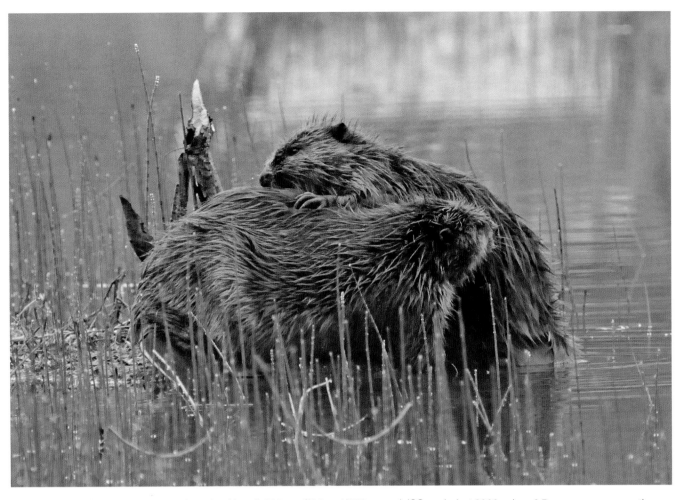

Nikon D-300, AFS Nikkor 70-300 mm lens, focal length 300mm, f/6.3 at 1/320 second, ISO equivalent 3200, minus 0.7 exposure compensation, 6/16/08.

Beavers grooming each other. When they're by themselves beavers groom their fur with their paws. But they also groom each other, which appears to have the additional function of social bonding. Mutual grooming is done by mouth, not by the paws, so I was quite excited to obtain a photo illustrating this. Getting up early in morning was important for getting images of this sort. This photo was taken at 5:25 a.m.

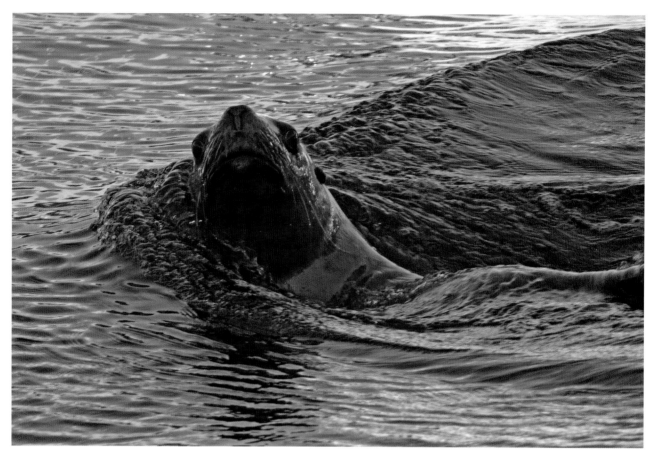

Panasonic DMC-FZ30, focal length 89mm, f/4 at 1/500 second, ISO equivalent 100, manual exposure.

Steller Sea Lion. Time of day can make a big difference in color. If the sun is low on the horizon, the colors are usually more vivid. In an Alaskan winter this can often mean almost anytime of the day, depending on the location. This photo and the one of the American Dipper on the next page are good examples of both time of day and time of year. Both of them were taken in Juneau during winter and early spring when the sun was low on the horizon. I especially like the colors that reflect in the water at this time of year.

This photograph was taken in a boat harbor in Juneau on January 14, 2006 at 3:32 p.m.

American Dipper. *This photo was taken in the evening of April 9, 2002, when the sun was quite low in the horizon.*

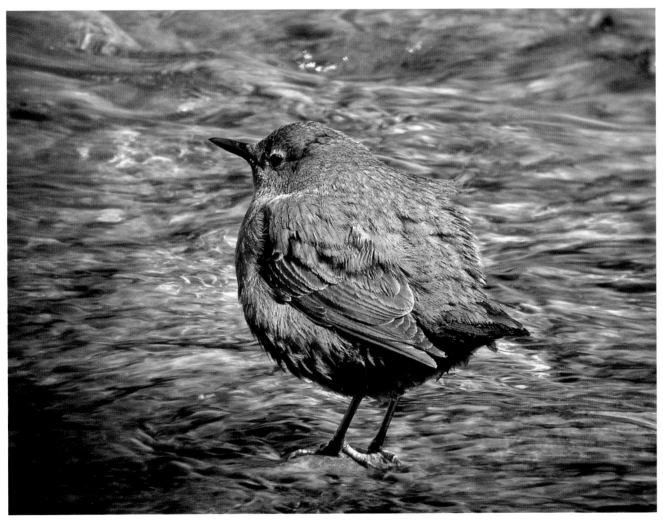

Nikon Coolpix E995, attached to a Kowa spotting scope with a 20 power objective, f/5.3 at 1/39 second, ISO equivalent 100.

Visit a Park

Nikon D-300, AFS Nikkor 70-300 mm lens, focal length 300mm, f/5.6 at 1/640 second, ISO equivalent 3200, manual exposure.

Parks can be good places to take photographs. I especially like some of the small roadside parks with ponds where waterfowl gather. Mallards often congregate in them, especially as a refuge during hunting season. It's fun to practice taking action photographs of the mallards when they fly about interacting with each other. All of these photographs of mallards were taken at Riverside Park in Juneau.

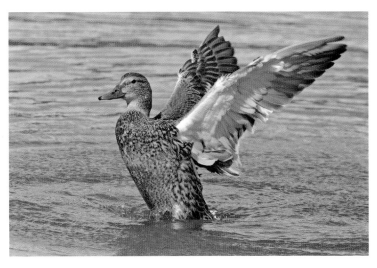

Nikon D-300, AFS Nikkor 70-300 mm lens, focal length 300mm, f/6.3 at 1/2000 second, ISO equivalent 400, manual exposure.

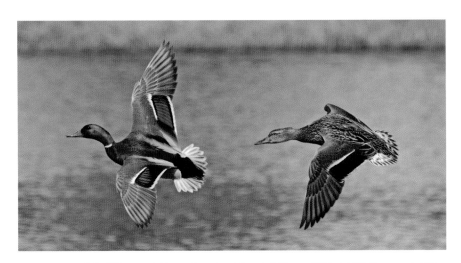

Nikon D-300, AFS Nikkor 70-300 mm lens, focal length 300mm, f/6.3 at 1/3200 second, ISO equivalent 400, manual exposure.

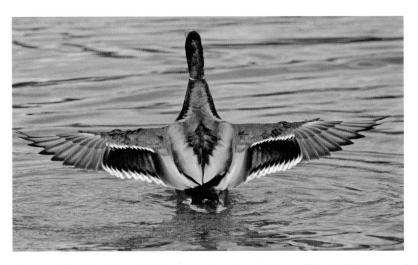

Nikon D-300, AFS Nikkor 70-300 mm lens, focal length 300mm, f/6.3 at 1/2000 second, ISO equivalent 400, manual exposure.

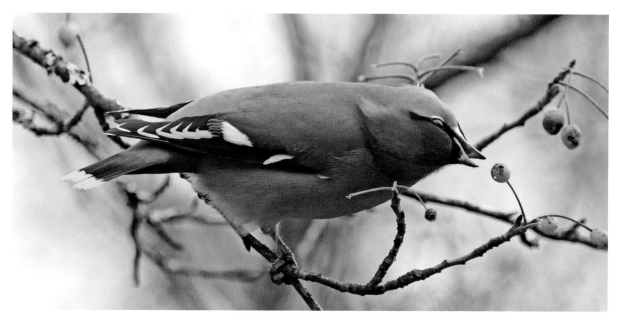

Nikon D-300, AF-S Nikkor 70-300mm lens, focal length 240mm, f/6.3 at 1/400 second, ISO equivalent 3200, no exposure compensation, 11/11/08.

Bohemian Waxwing. Mountain ash trees are usually planted in roadside parks in Alaska. In fall these trees produce abundant berries that attract many different species of birds (and sometimes bear). I often wander in amongst the trees looking for photo opportunities.

Sandhill Cranes. In 2009 I participated in Dragonfly Day at Creamers Field in Fairbanks. I took a break from the events and took a short hike and came across these cranes feeding on bumblebees that were feeding on the flower nectar.

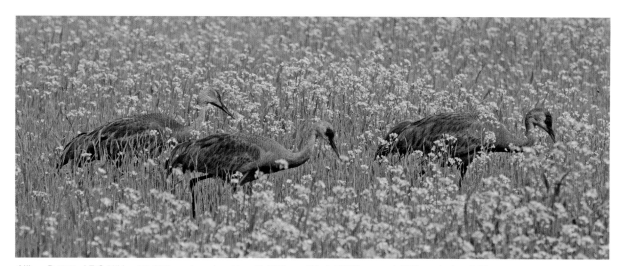

Nikon D-300, AF-S Nikkor 70-300mm lens, focal length 300mm, f/8 at 1/640 second, ISO equivalent 200, no exposure compensation, 6/27/09.

Put Up a Feeder

Feeding birds can certainly open up photo opportunities. As you thumb through this book you will see several examples where I have taken photos at or near a bird feeder.

I like red squirrels and have even put up a bird proof feeder just for the squirrels. Once a squirrel took over the bird feeder and used it to cache its cones. Occasionally crows and jays would arrive and discard the squirrels' cache. This seemed to infuriate the squirrel and it spent many hours chasing crows and guarding its cones.

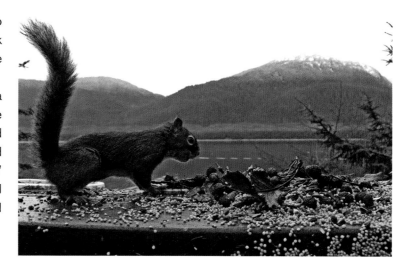

This was not a normal squirrel (if there is such a thing). It had an unusual habit of decorating its cache with mussel shells and leaves. It often spent many minutes rearranging its decorations. I nicknamed the squirrel "Bower," after male bower birds that decorate places in order to attract a female. Bower was with us for three years and provided many hours of entertainment.

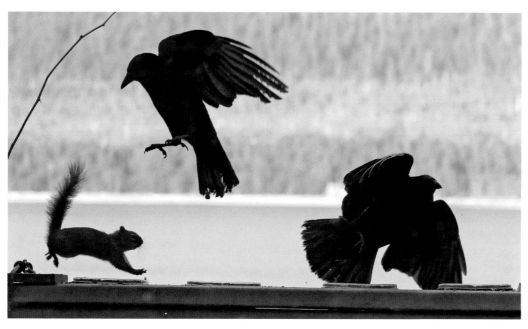

Feeding Bald Eagles fish remains after a successful fishing trip is a common practice among Alaskans, and I am no exception. It can offer some wonderful opportunities for practicing your photography techniques. The upper photo shows what a DSLR can do when the bird is coming towards you. For this photo I used a spot focus with the camera set in a continuous firing mode. Once locked into the bird the camera and lens automatically adjusted its focus despite the bird coming towards me.

The lower photo shows what a Prosumer camera can do with its greater depth of field. For this photo the camera was set near the salmon remains and triggered from inside the house.

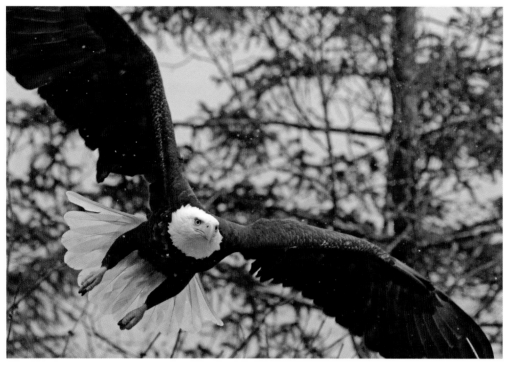

Nikon D-300, AF-S Nikkor 70-300mm lens, focal length 105mm, f/4 at 1/1000 second, ISO equivalent 1600, no exposure compensation.

Panasonic DMC-FZ-30, focal length 17mm, f/4 at 1/1000 second, ISO equivalent 100, minus 0.7 exposure compensation.

Types of Photographs

Scenery

Portraits

Connections

Just for Fun

For the Record

The Unexpected

Scenery

I do not take scenery photographs. Or do I? I usually tell people and myself that I am not interested in photographs of scenery. I have two excuses. Either I am more interested in documenting behavior or putting things in their environment (ha, can't that be scenery?), or I am color blind (which is true). However, when you are out and about in Alaska you can't help but be awestruck by the scenery around you, especially under certain conditions of light and weather. So I admit that sometimes I will grab a scenic shot or two. I am never sure what to do with them so I put them all in a folder labeled scenery and forget about them.

In reviewing photographs for this book I did open up the folder on scenery, and I found a few images that seemed worth sharing.

Panasonic DMC-FZ30, focal length 7mm, f/4.5 at 1/400 second, ISO equivalent 100, no exposure compensation, 6/22/09.

Lake in Kanuti National Wildlife Refuge. *One type of scenery photo can be one that reminds us of a special place. In that respect, I chose the photo of a lake some friends and I camped on in 2009 as the lead one for this section. The photo was taken at a remote lake in the Kanuti National Wildlife Refuge in northern Alaska. This refuge averages about a dozen visitors a year and, may be one of the least visited places in Alaska. We flew into this lake and stayed for a few days. The area showed no evidence of humans having been there and we heard no human-derived sounds once the plane left. It was a wonderful experience that I will never forget. We are so fortunate to have places in Alaska like this one.*

Bald Eagle and rising moon. *Another type of scene that is fun to photograph are ones of the rising moon. If it's fairly light out you can sometimes capture a creature, such as a Bald Eagle, in the same image.*

Panasonic FZ-18, focal length 83mm, f/6.3 at 1/500 second, ISO equivalent 100, minus 0.7 exposure factor, 1/19/08.

Full Moon/Full Frame. *I have gotten my best photos of the moon itself by using digiscoping. If I wanted to, I could then use Photoshop to put the moon in the scene of my choice.*

Nikon Coolpix E995 attached to a Kowa spotting scope with a 20 power objective, focal length 20mm, f/4.5 at 1/690 second, ISO equivalent 100, minus 1.3 exposure compensation, full frame, 12/20/02.

(Photo to the left) Panasonic DMC-FZ30, focal length 7mm, f/3.6 at 1/1000 second, ISO equivalent 100, minus 0.7 exposure compensation, 10/19/06.

Before

After

Rainbow at Mendenhall Lake. *When rainbows occur I am always tempted to photograph them. But one really got me excited. I was working on a book titled Life around Mendenhall Glacier and needed a photograph for the cover. A rainbow appeared in front of the glacier and I could see a bear sitting at one end of it. (See photo to the left.) I had just had surgery and was not supposed to be too active, but seeing that scene caused me to forget my discomfort, and I hurried the best I could to a position where the glacier would be visible in the background. When I arrived at the perfect spot the bear was sitting too far to the left, out of the scene. So I took a photo of the rainbow and the glacier, and one of the bear. You guessed it—I moved the bear into the scene in Photoshop. This is the only photo I have manipulated for a publication, and I still have mixed feelings about doing so.*

Panasonic DMC-FZ-30, focal length 27mm, f/11 at 1/500 second, ISO equivalent 100, no exposure compensation, 2/28/07.

Freshly calved glacier ice. *Glaciers and icebergs are favorite subjects for scenery photographs in Alaska. By using the prosumer camera I was able to get enough depth of field to bring in Mendenhall Glacier behind the piece of ice.*

Nikon D-300, AFS Nikkor 70-300 mm lens, focal length 180mm, f/10 at 1/800 second, ISO equivalent 3200, no exposure compensation, 7/17/08.

Feather and Sitka spruce with raindrops.
Other scenes that are nice to photograph are drops of water.

Nikon Coolpix E995, focal length 20mm, f/5.6 at 1/77 second, ISO equivalent 100, no exposure compensation.

115

Panasonic DMC-FZ-30, focal length 38 mm, f/9 at 1/800 second, ISO equivalent 100, manual exposure, 3/21/06.

Eagle Beach and Chilkat Mountains.
*The calm water in this inner lagoon
allowed for a beautiful reflection, while
out on the beach the waves were
breaking.*

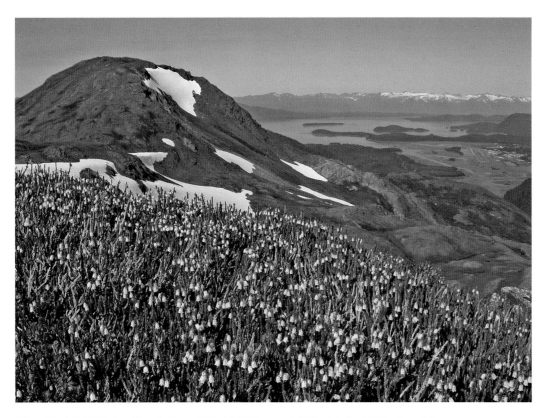

Nikon Coolpix E995, focal length 8mm, f/7.5 at 1/686 second, ISO equivalent 100, minus 0.7 exposure compensation, 8/4/02.

White mountain-heather on Mt. Juneau Ridge and White water crowfoot and Mt. McGinnis. *For scenery photographs these two represent my favorite subject. I really enjoy having the subject in the foreground, such as these flowers, and enough depth of field to show the surrounding environment.*

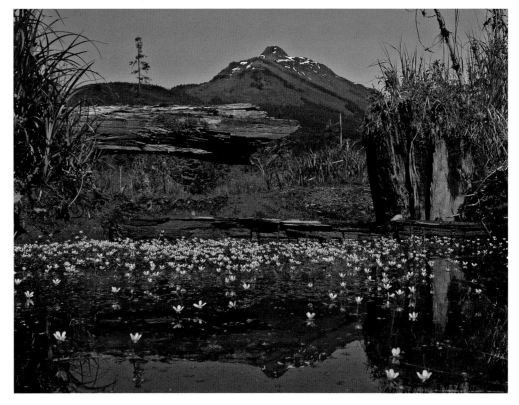

Nikon Coolpix E995, focal length 8mm, f/7.5 at 1/874 second, ISO equivalent 100, minus 1.7 exposure compensation, 6/6/03.

Portraits

Over the years I have probably taken many more portrait-type photographs than other types. Portraits that clearly show all a subject's identifying features are important for guide books, so I needed them for *Guide to the Birds of Alaska* and *Dragonflies of Alaska*.

However, I prefer photographs of creatures that depict some form of behavior or those that put the creature or flower in its environment. If I am in a situation to photograph a portrait and I do not need the photo for a guide book, I like to concentrate on the head and eyes. This is especially true if the creature is not looking at me.

Bald Eagle pair. I liked this portrait because the birds are no doubt a mated pair, and they seemed to be looking intently in opposite directions, probably for food. This photo was taken from about 100 feet away through a spotting scope.

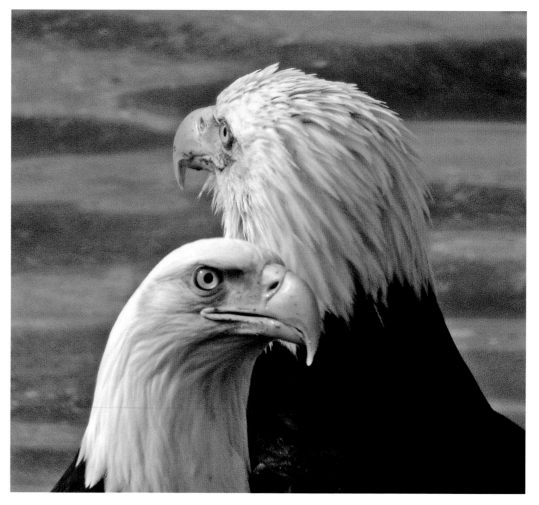

Fujifilm FinePix 4700 zoom camera, f/2.8 at 1/362 second, ISO equivalent 200, minus 0.6 exposure compensation, attached to a Kowa spottting scope with a 20 power objective. 4/11/02.

Black bear. *I liked this photo because the bear was looking off to the side and seemingly concerned about something other than myself. I also liked the unusual white blaze on its chest.*

Nikon D-300, AFS Nikkor 70-300 mm lens, focal length 220mm, f/5.3 at 1/80 second, ISO equivalent 3200, minus 0.7 exposure compensation.

Black wolf. *I have many photos of the wolf that likes to play with people's dogs in the Mendenhall Glacier area. But this photo was one of my favorites. It was taken from about 100 feet away through a spotting scope on a dreary snowy day. It was certainly not the razor-sharp image you can take with DSLR's on brighter days, but I especially liked the softness of the image and the concentrated look in the wolf's eyes.*

Samsung Digimax V70/a7 attached to a Kowa spotting scope with a 20 power objective, f/4.9 at 1/20 second, ISO equivalent 100, plus 1 exposure compensation, 1/25/07.

Nikon D-300, AFS Nikkor 70-300 mm lens, focal length 300mm, f/10 at 1/800 second, ISO equivalent 1000, no exposure compensation, 6/23/09.

Four-spotted skimmer dragonfly. *The top portrait of Alaska's official State Insect is a good example of portraits that DSLR's can take, especially if you are careful to include a plain background. In this case the background was a vegetated marsh.*

The dragonfly to the right was first captured with a net and then cooled down in a portable cooler. I then posed it so that all its field marks were visible. Since this was the official Alaska State Insect and since the mountains were visible in the background, John Hudson and I used it on the cover of our field guide to dragonflies in the state.

Nikon Coolpix E995, focal length 12mm, f/8.6 at 1/471 second, ISO equivalent 100, minus 0.7 exposure compensation, 5/19/03.

Connections

Nikon Coolpix E995, focal length 13mm, f/9 at 1/526 second, ISO equivalent 100, minus 1.3 exposure compensation, 8/4/02.

Fireweed on the Mendenhall Wetlands. *One of my very favorite photographic endeavors is to document some of the connections that exist in Alaska's natural world. Another is to document photographically an animal's behavior that is unusual.*

Reading about things happening in nature can lead to very interesting photographic opportunities. For example, one summer a friend told me about seeing tiny aphids and red ants on the top of fireweed plants. When I did some research about the connections between ants and aphids I discovered that the ants actually protect the aphids from some predators and may even take them into their nest for the winter. In turn the aphids produce drops of honeydew that provide food for the ants.

Beautiful fireweed plants line the Dike Trail near the Juneau Airport. It is a wonderful place to admire their beauty and to watch hummingbirds and bumblebees feeding on the flowers. I now look more carefully for aphids and ants, and I also like to see the warblers feeding on the aphids.

Bumblebee feeding on fireweed blossom.

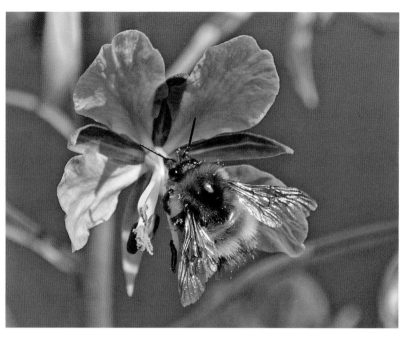

Nikon D-300, AFS Nikkor 70-300 mm lens, focal length 300mm, f/7.1 at 1/800 second, ISO equivalent 500.

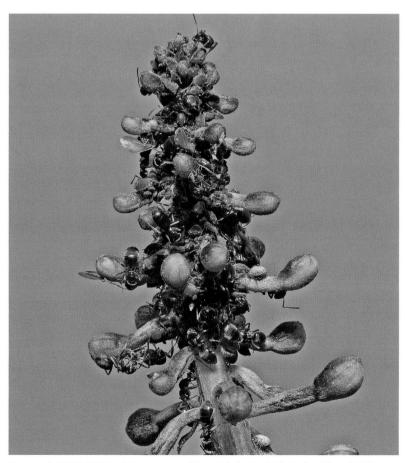

Aphids and ants on fireweed. *Look carefully at the top of the plant and you may see clusters of tiny insects called aphids and perhaps the red ants associated with them.*

Panasonic DMC-FZ30 with supermacro lens and electronic flash, focal length 10mm, f/9 at 1/200 second, manual exposure, 8/13/09.

123

With my supermacro lens in hand I was able to photograph the sequence of an ant stimulating an aphid, the honeydew being extruded, and the ant lapping it up. This was very challenging photographically because the aphids and ants were only a couple of millimeters long, and it required quite a bit of patience and searching to find each event happening. I was very pleased and excited to have seen and captured the events with photos. This also led me to think about and photograph a couple of other natural connections involving fireweed.

If you are lucky you may also find tiny red ants tending them. Later in the summer, during the southward migration of warblers, you may see Yellow-rumped Warblers feeding on the aphids. No doubt many other connections exist with fireweed.

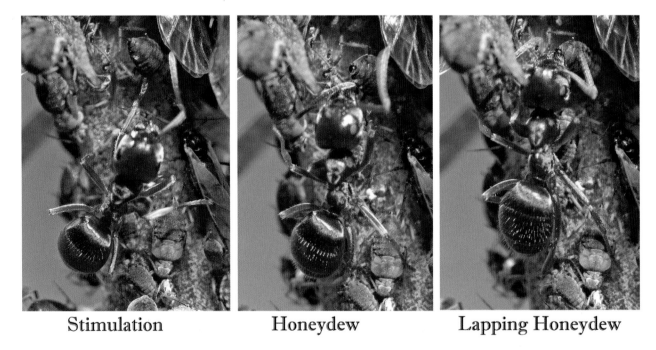

| Stimulation | Honeydew | Lapping Honeydew |

Panasonic DMC-FZ30 with supermacro lens and electronic flash, focal length 62mm, f/10 at 1/125 second, ISO equivalent 100, manual exposure, 8/20/08.

Red ant tending an aphid. *To get these photos I had to wait for a wind- free period. I used a tripod and searched for the right scene by using the LCD screen on the camera. This helped a great deal as the insects were so tiny it was difficult to see what was going on.*

Nikon D-300, AFS Nikkor 70-300 mm lens, focal length 300mm, f/5.6 at 1/500 second, ISO equivalent 3200, no exposure compensation, 8/16/09.

Yellow-rumped Warbler feeding on aphids. These warblers fed on the aphids for a couple of weeks. By standing still and waiting I was able to capture images of the birds feeding. I liked this photo because you could see the aphids stuck to this bird's bill.

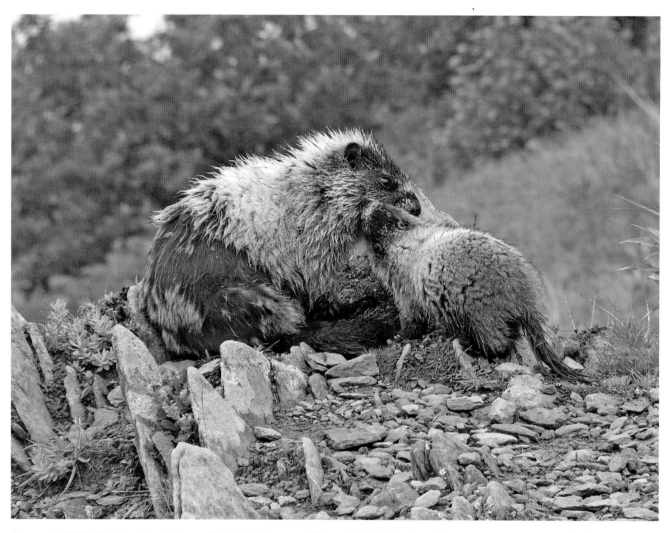

Panasonic DMC-FZ10, focal length 72mm., f/6.5, at 1/200 second, ISO equivalent 100, minus 0.7 exposure compensation, 7/11/05.

Female hoary marmot with young. *It is fun to document unusual behavior or appearance with a photograph and then attempt to determine the connection. Once, while taking photographs for our book on marmots I noticed that just after emerging from their dens some of the female marmots with young were missing fur from their hind end. I did not use any of these photos in the book because I thought the animals just didn't look as pretty as the other marmots.*

Some time after the marmot book was published I was watching a movie on Public Television about the life of coyotes. The movie showed a mother coyote with the fur missing from her hind end, and she looked just like the photos I had taken of the female marmots in the spring. The explanation in the movie was that the mother coyote pulled her fur out to line the den for the birth of her young. I immediately suspected that mother marmots may do the same thing. If that is true what a wonderful story that would have made for our marmot book.

I continued to try to find a plausible answer. In the literature I discovered that mother rabbits line the den with their own fur but could find no documentation of marmots doing so. I did find, however, a report that mentioned that some marmots partially shed their fur before going into hibernation. I may never know for sure why I was seeing mother marmots missing fur from their hind end but will continue to search for an answer.

Just for Fun

Nikon D-300, AFS Nikkor 70-300 mm lens, focal length 220mm, f/8 at 1/3200 second, ISO equivalent 1600, plus 0.7 exposure compensation.

Sometimes it's fun to think of how to get unusual photographs in places where birds and mammals are commonly fed by humans. By putting the food in certain places such as in your camera's sun shade or on the top of your head you can create fun images.

Also, certain types of photographs depict a rather humorous looking situation or there is a humorous story behind the photo.

Raven's Brew. *With the proliferation of coffee houses I noticed ravens playing with the cups that people discarded. I thought that it would be fun to get a photo of a raven picking up one of these cups. Then a friend gave me a new cup for Raven's Brew, a coffee roasted in Ketchikan and Anchorage, Alaska.*

I waited for a sunny day, then visited the parking lot of a grocery store adjacent to a coffee house where I knew ravens hung out. I placed the cup about 20 feet from my car and waited with rolled down window and camera. Within a few minutes about 5 ravens came and walked in a circle around the cup. Eventually one picked up the cup, and I got my photo. Of interest is that the bird eventually took off the lid, stuck its head into the cup, and drank the small amount of latte I had put there.

Photo by Noble Proctor

Black Currawong Attacking Bob. *At a couple of the lodges I visited in Australia these birds readily accepted food. I found that if I put a piece of food inside the lens cap they would fly up and grab it. Once I got set up, a friend took this photo. I sent one of the photos, showing the bird flying directly at the camera, to my stock agent. It was eventually sold to a magazine for an article on the dangers of wildlife photography, even though I had clearly labeled the photo with what I had done.*

Looking for Crimson Rosellas. *Again in Australia these beautiful parrots would readily accept food from people. When I put a piece of food on the camera they would often land on me before picking it off the camera.*

Photo by Noble Proctor

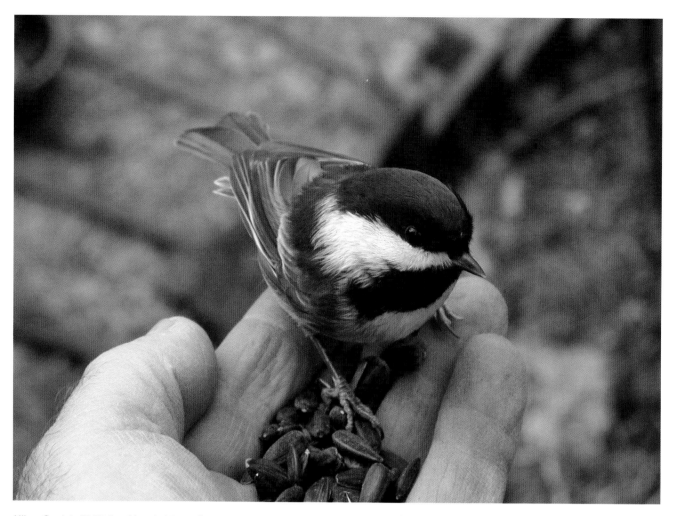

Nikon Coolpix E995, focal length 17mm, f/3.6 at 1/133 second, ISO equivalent 200, no exposure compensation.

A bird in the hand. *With some patience you can get chickadees that come to your feeder to also accept food from your hand. Sometimes I stand by our feeder with a hand full of sunflower seeds off and on for a few days. Eventually one or two chickadees will land on my hand and take a sunflower seed. This seems to stimulate the others, and now most of them will readily come and accept food from my hand. It's a thrill to gain the confidence of such a small creature and to also feel how light and delicate they really are. To get the photo I held a Nikon Coolpix point-and-shoot camera with my other hand.*

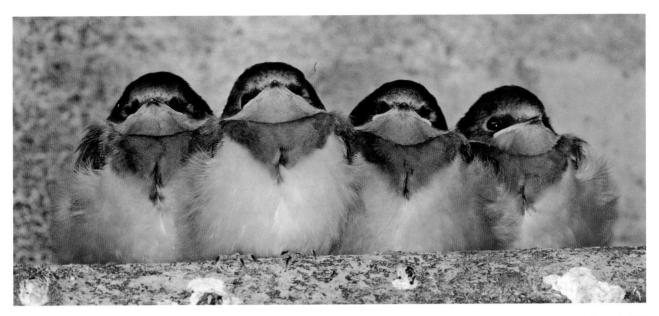

Nikon D-300, AFS Nikkor 70-300 mm lens, focal length 240mm, f/8 at 1/60 second, ISO equivalent 200, no exposure compensation, 7/14/08.

Waiting to be fed. *These four young Barn Swallows were waiting on a ledge above the restrooms at the Mendenhall Glacier Visitor Center. I felt rather strange focusing on this spot when a woman walked up to me and asked if I was photographing bears.*

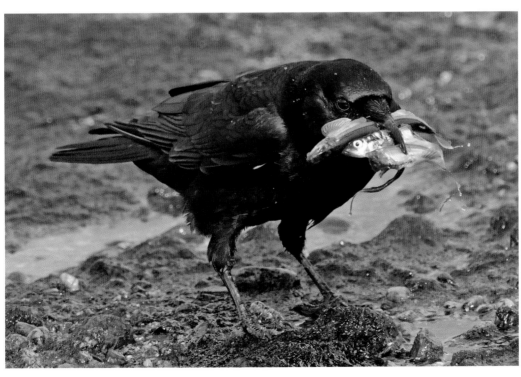

I want more! *While photographing Bald Eagles feeding on capelin this Northwestern Crow was walking about trying to pick up as many as it could.*

Nikon D-300, AFS Nikkor 70-300 mm lens, focal length 300mm, f/8 at 1/1600 second, ISO equivalent 1000, no exposure compensation, 5/4/09.

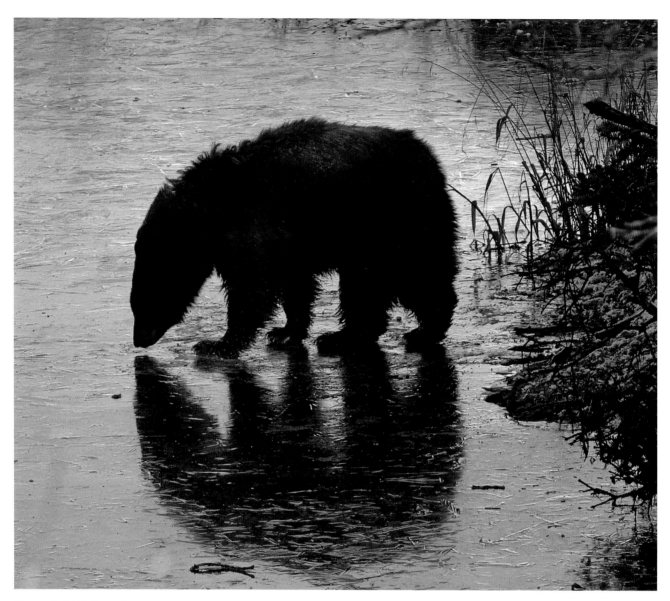

Panasonic DMC-FZ30, focal length 89mm., f/4, at 1/640 second, ISO equivalent 100, minus 0.7 exposure compensation, 11/3/06.

Last bear standing. *It was the time of year when most bears should have been hibernating. This young black bear was looking through the ice at a salmon carcass.*

For the Record

Photography is an excellent way to document new species, range extensions, banded bird records, and even unusual behavior for Alaska's creatures. The vast unoccupied areas of the state make photographic documentation even more important than it might be otherwise.

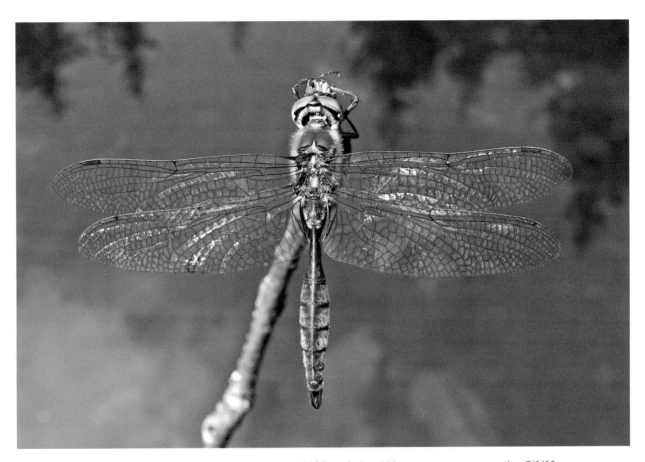

Panasonic DMC-FZ30, focal length 7mm, f/3.6 at 1/160 second, ISO equivalent 100, no exposure compensation, 7/9/09.

Ocellated Emerald Dragonfly. *This species was first documented for Alaska in the summer of 2009. John Hudson and I had traveled to the Kanuti Wildlife Refuge in northern Alaska with some personnel from the U.S. Fish and Wildlife Service. The purpose of the trip was to document the species of dragonflies that occur in the refuge. Much to our surprise we caught a new species for the state, a female Ocellated Emerald. For insects you really need a specimen for the record so we couldn't let this one escape. That meant I could photograph the insect only when it was hand held or after it had been preserved. I was really disappointed—but not for long.*

After we returned home John found Ocellated Emeralds at the outlet of Auke Lake in Juneau. So, using posed individuals that had been cooled down, I was able to get the photo needed for our updated edition of Dragonflies of Alaska.

Bird Records

New species of birds are added to the state list every year. For example, between the 1995 edition and the 2008 edition of *Guide to the Birds of Alaska* I had to add 37 species. Many of these were documented by photographs, since to officially add a bird to the Alaska list requires a specimen or an identifiable photograph. A written description alone is not acceptable.

Most birders and researchers carry cameras with them. Some of the point-and-shoot models can just be held against the eye piece of a spotting scope to obtain an identifiable photograph, and many prosumer models have telephoto capabilities approaching a lens equivalent of 600 mm. The small size and light weight of these cameras makes it easy to carry them, especially when your purpose is other than photography and you have other gear to haul around. Digital cameras automatically record date and time with each photograph, and that information can be retrieved easily by clicking on the image's properties (providing that you've set the camera's clock).

Scissor-tailed Flycatcher. This bird is an extremely rare visitor to Alaska, so when one showed up in Juneau on July 9, 2003, it was a very exciting event for local birders. Through digiscoping I was able to get a good enough photograph to document the bird's occurrence and help establish the record.

Nikon E995 attached to a Kowa spotting scope with a 20 power objective, f/5.1 at 1/83 second, ISO equivalent 100, minus 1.3 exposure compensation.

Banded Snow Goose. *A male Snow Goose seen on Juneau's Mendenhall Wetlands May 3, 2002, had hatched in summer 2000 and been banded on July 14, 2001, on Wrangel Island, at 72 degrees N in Russia's Chukchi Sea. The photograph that I took by digiscoping helped establish this record.*

Nikon Coolpix E995 attached to a Kowa spotting scope with a 20 power objective, f/5.1 at 1/156 second, ISO equivalent 100, minus 0.7 exposure compensation.

Samsung Digimax V70/a7 attached to a Kowa spotting scope with a 20 power objective, f/3.6 at 1/640 second, ISO equivalent 100, minus 1 exposure compensation, 9/7/06.

A Ruff in Juneau. *This Asiatic shorebird occasionally shows up in southwestern and western Alaska. To have one appear in Juneau was very exciting for the local birders. It was a very rainy day but by holding an umbrella over the camera equipment I was able to document the occurrence from about 80 feet away.*

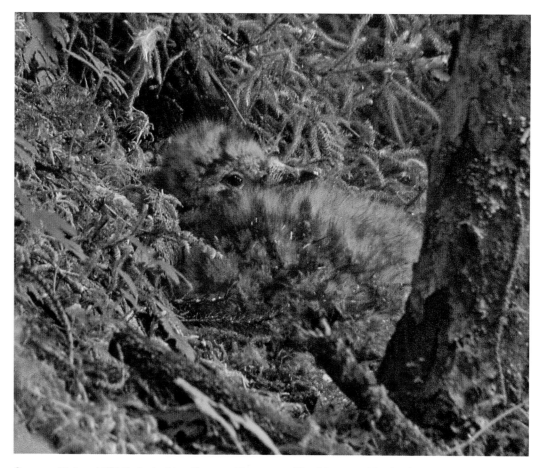

Samsung Digimax V70/a7 attached to a Kowa spotting scope with a 20 power objective, f/4.9 at 1/6 second, ISO equivalent 200, minus 1 exposure compensation, 8/20/09.

Marbled Murrelet chick about 23 days old. *An exciting life experience occurred for me in the summer of 2009. A couple of friends found a ground nest of a Marbled Murrelet. Very few ground nests of this bird have ever been found. My friends wanted to document the development of the chick and invited me along to take photographs. Very few photos of these chicks exist, and documentation of their development through photographs is rare, so I agreed. It was a real photographic challenge. We had to hike for about an hour up a fairly steep area with no trail, to a point at the top of a waterfall. If we were not to disturb the bird, we could view the nest from only about 82 feet away. Overcast skies and intermittent rain, in addition to a fairly dense tree canopy, provided relatively poor conditions for photography.*

I tried my DSLR and long telephoto lens, but the chick was way too small in the photograph. I decided to use digiscoping, which at about 2,300 mm lens equivalent gave acceptable results. It was so dark, however, the photographs had to be taken at 1/6 of a second shutter speed. This meant the equipment had to be rock steady. Obtaining fairly sharp photographs was important because we wanted to publish the results. A sturdy tripod, Bogen Junior Geared Head, and a self timer helped to achieve acceptable images.

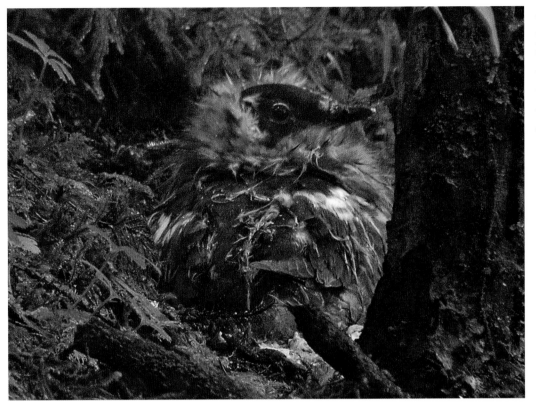

Samsung Digimax V70/a7 attached to a Kowa spotting scope with a 20 power objective, f/4.9 at 1/6 second, ISO equivalent 200, minus 1.5 exposure compensation, 8/28/09.

Marbled Murrelet chick about 31 days old. *At this age the chick has started to lose its down feathers, and its black and white juvenile plumage is showing.*

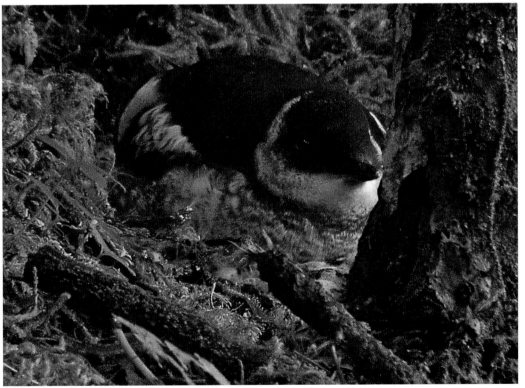

Samsung Digimax V70/a7 attached to a Kowa spotting scope with a 20 power objective, f/4.9 at 1/6 second, ISO equivalent 200, minus 1.5 exposure compensation, 9/1/09.

Marbled Murrelet chick about 35 days old. *Here the chick has lost all of its down plumage and is ready to fledge. It left the nest within 24 hours of this photo being taken. The bird had to fly on its own through the forest about three-quarters of a mile to salt water. Once there it had to feed on its own as the parents would no longer care for it.*

Harbor seal rescue. I was once involved in helping to rescue a stranded harbor seal pup that had been abandoned by its mother. The newborn pup was found on the Mendenhall Wetlands in Juneau. After a few days, when it appeared that the pup's mother was not caring for it, help was called in. The marine mammal rescue coordinator for the National Marine Fisheries Service, and a veterinarian who came to examine the pup concluded that it would not survive without help, so it was shipped north to the Sea-Life Center in Seward for rehabilitation.

Three months later the harbor seal was returned and released in Fritz Cove, near where he had been found. Fitted with a radio transmitter, he was tracked venturing up the Taku River, and eventually spending most of his time near Glacier Bay.

I was glad that I had taken photographs of the event, and vividly remember my encounter with the pup. When I first knelt down to photograph him, the pup started crying and waddled towards me almost as if to say, "Please help me." When I photographed his release three months later, he turned and stared at me. What was he thinking?

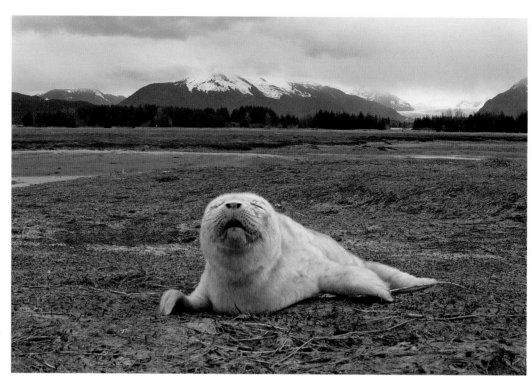

Panasonic DMC-FZ30, focal length 7mm, f/7.1 at 1/320 second, ISO equivalent 100, minus 0.7 exposure compensation, 5/10/07.

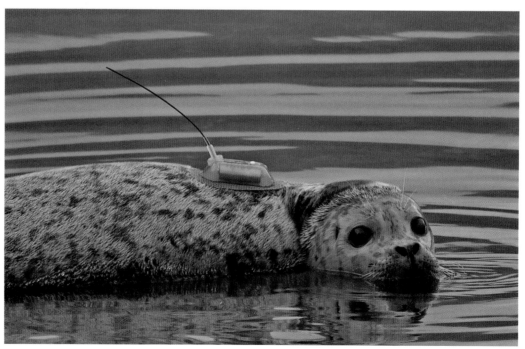

Panasonic DMC-FZ30, focal length 89mm, f/3.7 at 1/250 second, ISO equivalent 100, minus 0.7 exposure compensation, 8/4/07.

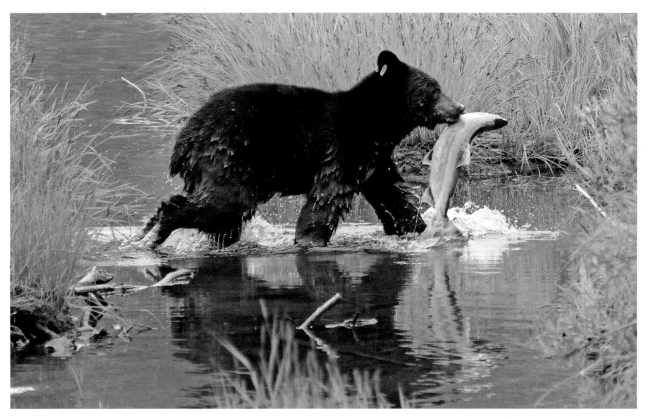

Nikon D 300, AFS Nikkor 70-300 mm lens, focal length 300 mm, f/5.6 at 1/640 second, ISO equivalent 3200, no exposure compensation, 8/12/09.

Photography can help a great deal to document the movements and presence of animals that have been marked. Often the photographer may not be aware of the research but by contacting certain agencies he can find out the history of the animal. This not only enhances the photographer's knowledge but can contribute significantly to the research.

Tagged black bear. *In 2007, when this bear was still with its mother, it was marked with an ear tag. At that time, the mother, this bear, and its sibling were getting into garbage in the Juneau area. In 2008, the two cubs left their mother. In 2009, the mother was still a garbage bear, and the other cub had been captured and sent to a zoo, but it appears that this bear has returned to eating natural food.*

American Dipper with leg bands. *From the leg bands on the American Dipper we know that it is a female and that she successfully raised four chicks in 2009. The photograph provides further documentation that these small birds capture and eat fish. The species she has caught is a young coho salmon.*

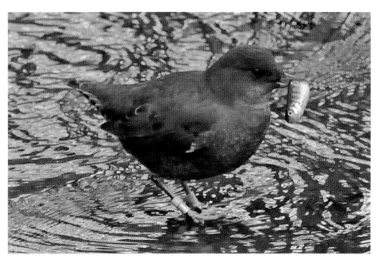

Nikon D 300 , AFS Nikkor 70-300 mm lens, focal length 300mm, f/8 at 1/800 second, ISO equivalent 3200, no exposure compensation, 10/6/09.

139

Photographing a new species. *What a thrill to be the first person to photograph a new species in its natural habitat. Manophylax alascensis, a species of caddisfly, was first discovered at Nugget Falls near Mendenhall Glacier in June of 2002. John Hudson, one of the authors of the paper describing this new species, took me to the site. We saw several of the tiny larvae with their beautifully crafted cases clinging to vertical walls with water flowing over them. The scientists who discovered these caddisflies had collected, preserved, and drawn pictures of the specimens. Apparently I was the first one to actually photograph them in situ.*

It was a challenge but the supermacro lens and electronic flash worked. To avoid reflections on the water I had to overcome natural light completely. A steady tripod and focusing rail helped a great deal.

Panasonic DMC-FZ30, focal length 64mm, f/5.6 at 1/125 second, ISO equivalent 100, manual exposure. Raynox DCR-250 achromatic close-up lens, Sunpak 333 electronic flash set at 1/16 power.

The Unexpected

Most good nature photographs are planned. Doing the research, whether it be the literature or visits to the site, can really help you get the best images. However, I'll have to admit, many of the photographs that were totally unexpected for me have been some of my most memorable experiences.

Nikon D3, Micro-Nikkor 105mm lens, electronic flashes.

Crab spider. About 35 years ago I was prowling about a bog with my Nikon film camera and macro set up and came across this crab spider hunting on a Labrador tea flower. While I was taking the photograph I didn't even notice the small blackish spider on top of the large spider. When I developed the film I thought how strange it was and had no idea what was going on. Much later a friend and I were doing research for an article on crab spiders and discovered that the males are blackish and very small. Also, for mating, they must sneak up on the female to avoid being eaten. The photograph ended up being the lead photo for our article titled "Charlotte without a Web."

Nikon D-300, AFS Nikkor 70-300 mm lens, focal length 70mm, f/13 at 1/1250 second, ISO equivalent 1000, no exposure compensation, 10/13/08.

Black bear and Mendenhall Glacier. *I have always enjoyed taking photographs of creatures that depict their location. Although I had tried for a couple of years, I had been unsuccessful at getting a good photograph of a bear with Mendenhall Glacier in the background. One day the completely unexpected happened. I noticed a porcupine slowly wandering along the shore of Mendenhall Lake. I saw an opportunity to photograph it with the glacier in the background, so I lay down on the sand and waited for it to wander in front of me.*

Suddenly a man came up behind me and yelled "Oh my gosh, there's a bear!" That scared the porcupine away and ruined my photo opportunity. Then the intruder, camera in hand, ran down the beach a couple of hundred feet to where the bear apparently had been. Meanwhile, the bear had gone into the brush and emerged right next to where the man was standing. At that, the man ran back towards me shouting, "Get out of here! The bear is coming!" I continued to lie right where I was, and the bear calmly walked in front of me. At last I was able to get a photograph I had always wanted.

Nikon D-300, AFS Nikkor 70-300 mm lens, focal length 195mm, f/8 at 1/1000 second, ISO equivalent 400, no exposure compensation, 5/29/08.

The deer and the Mew Gull. *Once as I was visiting an Arctic Tern and gull nesting colony near Mendenhall Glacier, a Sitka black-tailed deer unexpectedly wandered into the area. The gulls and terns immediately and persistently attacked the deer until it leaped out of the water and ran from the area. I was glad I had my camera ready for action.*

Nikon D-300, AFS Nikkor 70-300 mm lens, focal length 112mm, f/5.6 at 1/4000 second, ISO equivalent 3200, no exposure compensation, 8/6/09.

Not in my backyard. *The Mendenhall Glacier area has always been one of my favorite areas for encountering the unexpected. On one of my wanderings I got really excited when a Great Blue Heron was flying by. I saw an opportunity to photograph the bird in flight with the glacier in the background and got a very nice shot. Then the heron lit on top of a covered viewing area where Barn Swallows nest. One pair of the swallows had had their nest and young destroyed by Steller's Jays that year, and they were attempting to nest again. The swallows became intent on driving the heron away. Eventually they drove it to a nearby tree and continued to harass it until it left the area. Watching all the action, I kept my camera in continuous firing mode and at 6 frames per second and a high shutter speed, I was able to capture the event.*

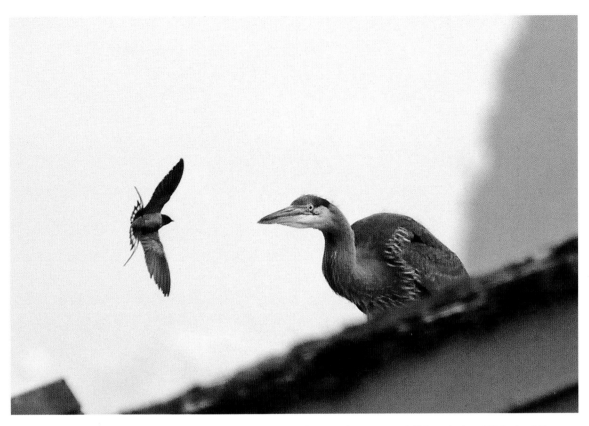

Nikon D-300, AFS Nikkor 70-300 mm lens, focal length 300mm, f/5.6 at 1/4000 second, ISO equivalent 3200, plus 0.7 exposure compensation, 8/6/09.

Nikon D-300, AFS Nikkor 70-300 mm lens, focal length 300mm, f/5.6 at 1/2000 second, ISO equivalent 3200, plus 0.7 exposure compensation, 8/6/09.

145

Nikon D-300, AFS Nikkor 70-300 mm lens, focal length 300mm, f/8 at 1/3200 second, ISO equivalent 1600, no exposure compensation.

I want your spot. Once in a harbor I was watching a line of gulls on a railing. They were so packed in that there was no room for any more. I thought the scene was pretty boring, with not much action from a photography standpoint. Then unexpectedly a gull flew in. It landed on top of one of the standing gulls, bit it on the neck, and took over its spot. Once again I was glad I had my camera ready and set up for action.

Nikon Coolpix E995, focal length 31mm, f/5.1 at 1/109 second, ISO equivalent 100, no exposure compensation, 7/30/02.

A mound of toadlets. While doing a study of the distribution of amphibians in the Juneau area I came across this mound of tiny western toads. To keep them from scattering at my approach, I had to slowly sneak up on them. I had not seen this mounding behavior before and had no idea what it meant, but when I did research for our final report I came across a reference to this type of behavior.

Apparently once they emerge from their aquatic tadpole stage and before dispersing, these young toadlets gather in these large mounds. Why they do this seemed to be unclear. One article thought it may help to conserve warmth. Since they are probably all brothers and sisters I thought it might be a final get-together before everyone headed out to the woods. Once they disperse, toads lead solitary lives on land until they return to their natal pond for mating two to three years later.

Later I was able to photograph one of the toadlets dispersing and thought it captured the sense of a youngster facing an uncertain future.

Nikon Coolopix E995, focal length 15mm, f/4.8 at 1/85 second, ISO equivalent 100, minus 0.7 exposure compensation, 9/2/02.

Crab spiders. *On one hike across a bog I came upon what looked like a fly standing on its head. On closer examination I saw a very camouflaged crab spider holding it. These spiders can change their color to match the flower they are hunting on.*

A little further on I saw what appeared to be a bumblebee floating upside down between two plants. Again upon closer examination I saw that another crab spider had secured the bee with silk and was feeding on it. I had read that these spiders were capable of catching prey larger than themselves so I was very pleased to observe and photograph the event.

Fujifilm Fine Pix 4700 point-and-shoot camera.

Fujifilm Fine Pix 4700 point-and-shoot camera.

Both of these events were unexpected and point out the importance of always carrying a camera with you. I was so glad to have my light weight point-and-shoot camera along. Ironically I have never seen these events again, even when I was purposely looking for crab spiders.

Pigeon Guillemots. *On a walk along an island beach I unexpectedly came across these guillemots standing on a rock. They were very tame and allowed me to approach for photography. I especially liked the look that two of them were giving to the one with a fish.*

Panasonic DMC-FZ-30, focal length 89mm, f/7.1 at 1/1000 second, ISO equivalent 100, minus 0.7 exposure compensation, 7/10/06.

Bonaparte's Gull and capelin. *While photographing Bald Eagles feeding on capelin this gull flew by with a struggling fish in its beak. The fish managed to break loose and I was able to capture the bird attempting to retrieve it. As I remember the fish got away.*

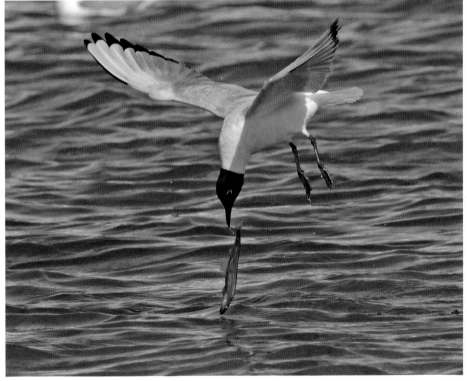

Nikon D-300, AF-S Nikkor 70-300mm lens, focal length 300mm, f/10 at 1/5000 second, ISO equivalent 1600, minus 0.7 exposure compensation, 5/2/09.

Great Blue Heron with Dolly Varden. *While photographing bears feeding on salmon this heron walked in front of me, grabbed a Dolly Varden, quickly swallowed it and flew off. It was an unexpected event.*

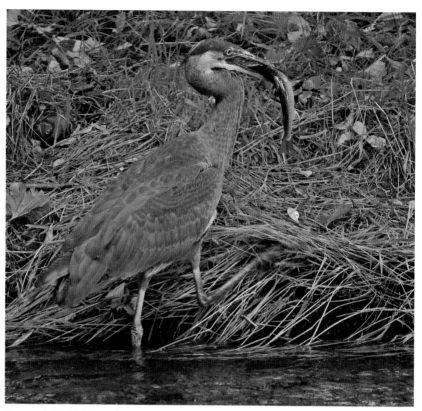

Panasonic DMC-FZ-30, focal length 89mm, f/3.7 at 1/80 second, ISO equivalent 100, minus 0.7 exposure compensation, 8/30/06.

Harbor seal and salmon. *While watching salmon migrating up a fish ladder and into a local hatchery this harbor seal suddenly appeared and grabbed one of the salmon.*

The marks on the side of the salmon indicate that it had once escaped a gill net only to be nabbed by a seal near its final destination. However, its fate once it entered the hatchery was not good either.

Panasonic DMC-FZ-30, focal length 61mm, f/3.6 at 1/640 second, ISO equivalent 100, minus 0.7 exposure compensation, 10/6/06.

Using Your Photos
Suggestions from my own Experience

I have 5 file cabinets full of 35mm slides. The birds, of course, are organized by species. Everything else is catalogued as mammals, plants, insects, fungi, lichens, or scenery. Most are housed in the newer slide holder sheets, but those housed in the older ones have started to deteriorate. I also have file folders titled "Best Birds," "Best Plants," etc. so at least I can quickly retrieve the ones I consider classic.

To convert slide images to digital I have a Nikon Super Coolscan 4000 ED slide scanner. This seems to work ok, but I have noticed that many of the most used slides have scratches and spots which usually need to be cleaned up in Photoshop.

Digital photos are certainly much easier to work with. I try to file these by species but have trouble keeping up with it. If I work on an image I title it "modified" and save the original and title it "original." I also file my very best, once in a lifetime type photos, in a folder titled "Best Photographs" and save both the original and modified images in this folder with the same title.

All digital images are backed up on an external hard drive. Once in awhile I back up my entire digital image collection on another external hard drive and put it into a safety deposit box at the bank. The yearly fee is well worth it. When I am working on a special project, like a book, I will back up the project on CD's with a date and carry them in the car. You never know!

I really do very little modification of my photographs. I have taken university courses in Photoshop and had the latest versions, but I got tired of spending the time needed at the computer. Also, I thought manipulated photos looked too sharp, too colorful, and not at all what I remember seeing. My goal is to make the image as natural looking as possible. If it is a drab day, the image should look drab.

So, I have gone somewhat backwards and now use only Photoshop Elements. For almost every image I am working with I do the following: resize it to 300 dpi (the quality needed for publication), crop, work with it in Shadows and Highlights, apply Unsharp Mask once, and save it as a .tif. My photography friends say I should be taking my images in the Raw format. I have tried it, but being color blind I found manipulating the various colors confusing. I have been told that there is a way to overcome this problem and have promised myself to reinvestigate using Raw. For now I use only the .jpeg images that the camera produces.

Earning a living

I do sell photographs and have dabbled from time to time in selling prints. I have many of my best 35mm images housed with a stock agent in New York (Animals/Animals). They sell the images throughout the world and I get roughly 50% of what they make. I have not taken the time to provide them with digital images, but I intend to do so some day. Prints sell fairly well at public markets, but I haven't figured a good way to market them otherwise. Note cards and post cards also do ok, but the profits from them are so low as to hardly be worthwhile.

I have the start of a website that my daughter put together for a university class project. I don't sell photos or books through the website but have a link to a local bookstore. A dream of mine has been to put together a web site that would be one-stop shopping for anything to do with nature in Alaska. There is so much information from various agencies and groups that is free. It would be nice to have it all in one place. Someday . . .

The most pleasure I have from photography is to use the images in articles and books that I write either by myself or with co-authors. It has

always been my philosophy that if something is worth doing, do it well enough so that it can be shared with others. Throughout my career with the Alaska Department of Fish and Game I usually published the results of my various projects. This was not a requirement of the job but gave me much satisfaction.

Write a column

Writing stories with photos about nature in Alaska for newspapers or magazines can be very satisfying even if you don't make much money. Over the years I have found a couple of publications that would accept articles and photos on a monthly basis. If you do this for a few years you will gather enough information and photos for a book, and it is relatively painless.

One example is how *The Nature of Southeast Alaska* came to be. In 1985 two friends and I began writing a monthly column on nature for the *Southeastern Log*, a newspaper published in Ketchikan and distributed free to all residents of Southeast. The *Log* essays provided the seed that grew into this book. Each month one or all of us would write the column and I would submit a photograph to accompany it. Sometimes I would have a photo already and sometimes a column idea would cause me to take some photographs. This was great because it often pushed me in photographic directions I might not have otherwise gone into.

Even if you don't get paid for your photographs using them like this helps build your knowledge and image collection. Eventually, who knows? A book may be lurking in the future.

I learned one important lesson from this book. The cover photograph can make or break the sales of a book. At one time the sales

of the book had dropped to a point that the publishers were considering discontinuing it. They decided to put a different photograph on the cover and see what would happen. Well, the sales doubled.

The original edition had a breaching humpback whale on the cover. I was told that breaching humpback whales were being overused and were not as popular anymore as a book cover. The photo the publisher chose was a beautiful image of the Mendenhall Glacier by Mark Kelley.

Use photos from stock agencies

Sometimes it's nearly impossible to gather all the images yourself to cover a subject. For the latest edition of my bird guide I attempted to get the best bird photographs I could and to cover all species in the state with photographs. Although I had photos of many more species than in the previous edition I still had to purchase a lot to complete the coverage.

Visual Resources for Ornithology, The

Academy of Natural Sciences (VIREO) has the best collection of bird images that I am aware of. Their web site was very easy to work with, and the images I needed could be transferred to a site for ordering. The images were then uploaded to a site in which I could then download them to my computer. It was all done over the internet!

Self-publish

Self-publishing has been the best outlet for and the most fun use of my photographs. It all started when Marge Hermans and I decided to try self-publishing the book titled *Southeast Alaska's Natural World.*

For several years Marge and I had been writing monthly articles on nature for a magazine called *The Alaskan Southeaster.* So we decided to revisit the articles, update and rewrite them, write introductory sections, and put them all together in a self-published book. We also decided to do all the design ourselves. It was especially exciting for me because the book would be heavily illustrated with my photographs.

This book was the beginning of an endeavor that I consider to be the best outlet and use of

Along the
Mt. Roberts Trail
in Juneau, Alaska

Robert H. Armstrong
Marge Hermans

photographs. Self-publishing allows you to have complete control over the product and to use images however you would like. If you take the time to learn a design program, have most of the photos needed for the project, and do the research for the writing, you can keep the cost of self-publishing to a minimum.

For this book and all other self published books I have gone through a print broker. These print coordinators usually deal with good quality printers and have always been very reliable. Their bids include the shipping cost to wherever you want books sent.

In general, you have to order at least 1,000 to 1,500 books to keep the cost per book reasonable enough to make a profit. If you think you can sell them, quantities of 3,000 to 5,000 usually get an even better price per book.

I have been satisfied by the printing quality of my photographs in the self published books. I am always amazed by the process. You convert the designed book to a PDF, it's shipped electronically to a printer, and you get page proofs back in a couple of weeks.

I have always used a local professional designer to do the final tweaking of the books before it's sent to a printer. All images have to be converted to CMYK, which my Photoshop program will not do, so I have the designer do this and check them over for color problems. Also, since the cover is so important I have the designer do the final cover design.

Concentrate on a local area

By concentrating photography in a relatively small area I learned fairly quickly how, where and when to take the best images.

Two books in particular (*Along the Mt Roberts Trail in Juneau Alaska* and *Life around Mendenhall Glacier in Juneau, Alaska*) were especially rewarding to me.

Southeast Alaska's
Natural World

Amphibians
Birds
Fish
Insects
Mammals
Plants
Other Natural
Things

Robert H. Armstrong
Marge Hermans

The rock burrow may not be as warm
as a burrow deep in the soil,

but it is safer from predators
such as black bears,
who might otherwise
dig into the den.

The bear story, thanks to the clapping man

As a photographer these were great projects. For one book I spent numerous days wandering about the alpine, my favorite habitat, taking photographs. I was always amazed by how confiding the different alpine creatures became after seeing me day after day.

Whistlers
on the **Mountains**

Robert H. Armstrong and Marge Hermans

One book may lead to another

While taking photographs for the Mt. Roberts book I had accumulated a lot of hoary marmot images. So Marge and I decided to do a children's book titled *Whistlers on the Mountains*.

This was a reasonably easy project to gather photos for. A couple of marmot families accepted my presence well and provided many neat photo opportunities.

One funny thing happened on the project. As I was walking down the trail a black bear was coming up. I stopped and got my camera out, ready to take its photo. I was excited because I needed a photo of a bear in the alpine for the book. Just then someone came up behind me. I motioned to him that I was about to photograph this bear. He immediately started clapping his hands and yelling which scared both me and the bear. The bear ran down the hillside and stopped momentarily at the bottom of a rock slide, where a family of marmots lived. I got a photo of the bear looking into the rocky area, which fit in perfectly with our story. I did not thank the man for clapping.

Something that hasn't been done before

When choosing a book project I think it is important to look carefully at what has been done before. Try to make your project completely new or a much different approach than similar books.

Dragonflies of Alaska is a good example of this. When I decided to do the book no other book had been written about dragonflies in Alaska.

The book idea started a number of years ago when Marge Hermans and I interviewed John Hudson for an article we were writing about dragonflies. John and I soon became friends and decided to publish a book together covering the dragonflies of Alaska. It was a

manageable project because we needed to cover only around 30 species. John and I traveled about the state gathering specimens and taking photographs.

It was an interesting photography venture. In order to take good photos of the different species and to show their field marks we decided to use posed insects. To do this we captured them in nets. This is not an easy task but John was good at it. Then I put them in a plastic envelope and transferred them to a portable cooler. Once they'd cooled down we could pose them on the perch of our choice for photography. Just before they were warm enough to fly and looked the most natural I would take their photos.

We also needed to take photographs of dragonfly behavior for the book. This was a little more challenging and required some patient sitting in marshes and along lake shores.

To help save a creature or an area

A very satisfying project can be to write and illustrate a book about a creature or area that is in danger of being harmed. Books can be a good way to raise public awareness and, hopefully, prevent harm or damage from occurring.

One example of this is the book Mary Willson and I did on the beavers of the Mendenhall Recreation Area. Beaver activity in this area was flooding some of the hiking trails. The stated solution, at the time, was to eliminate them by trapping.

A number of volunteers joined together to alleviate some of the flooding and postpone trapping the beavers. In the meantime Mary and I thought a book about them would help raise awareness of the importance of beavers to the overall ecology of the area. I believe it has helped. Naturalists take children on field trips into the area and discuss the importance of beavers. Mary and I have talked about beavers to school children and made sure our book is available in all of the school libraries.

I had a great time taking photographs for this project, although, it did require being on the job at the crack of dawn. A couple of beaver families eventually accepted my presence and would play, groom, eat, and build dams within good photographic distance. One young beaver would consistently sit a few feet from me and stare. Perhaps he was contemplating a book about those crazy humans!

Doing a project of this sort is one way a photographer can contribute to saving a species of wildlife from being killed and to make sure it will be available for others to photograph and enjoy.

Another example of using writing and photography to help save an area is the book three friends and I produced on the Mendenhall Wetlands. Because this area lies within a major urban area it is under constant threat of destruction and alteration. A number of us concerned about the wetlands decided it would help to write a book about the area.

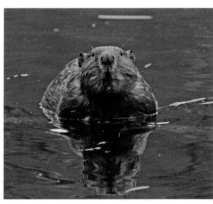

At the time Southeast Alaska Land Trust was heavily involved in using mitigation funds available for the Juneau International Airport expansion and was attempting to purchase accreted wetlands claimed by adjacent land owners and to put these lands back into refuge status. We proposed that an attractive and informative book could help them convince land owners of the importance of these wetlands, so the Land Trust agreed to fund most of the printing of the book, while my co-authors and I constructed the writing, photographs, and design.

Print on demand

Another way of getting your photographs in books is to go through a print-on-demand process. If you do all the work yourself – layout, photos, etc then the out-of-pocket expenses equal only the cost of a limited number of books. You can have only one or a few books printed. This is a great way to use your photos. You can make books of your images for presents or just to give to friends. If you want to do more the on-demand printers will help market your book for an additional fee.

I checked the quality of one of the on demand printers. For two of my books I submitted nearly the same PDF to one of the print-on-demand places that was submitted to the overseas printer. The copy I got back from the print-on-demand outfit was not quite the same quality of printing as done overseas but it was still quite acceptable. The only real difference seemed to be in the paper used. The color and sharpness of the photographs seemed about the same.